MANGA
IN
THEORY
AND
PRACTICE

**THE CRAFT OF
CREATING MANGA**

MANGA IN THEORY AND PRACTICE

THE CRAFT OF CREATING MANGA

HIROHIKO ARAKI

TRANSLATED BY
NATHAN A. COLLINS

viz media
SAN FRANCISCO

MANGA IN THEORY AND PRACTICE: THE CRAFT OF CREATING MANGA
ARAKI HIROHIKO NO MANGAJYUTSU by Hirohiko Araki
Copyright © 2015 LUCKY LAND COMMUNICATIONS
All rights reserved.
First published in Japan in 2015 by SHUEISHA Inc., Tokyo.
English translation rights arranged by SHUEISHA Inc.

Cover and interior design by Sam Elzway and Shawn Carrico
Translation by Nathan A. Collins
Lettering and touch-up by Mark McMurray

Published by
VIZ Media, LLC
P.O. Box 77010
San Francisco, CA 94107

www.viz.com

Library of Congress Cataloging-in-Publication Data

Names: Araki, Hirohiko, 1960- author. | Collins, Nathan, translator.
Title: Manga in theory and practice : the craft of creating manga / by
 Hirohiko Araki ; translated by Nathan A. Collins.
Description: San Francisco, CA : VIZ Media LLC, 2017. | Series: Manga in
 theory and practice ; 1
Identifiers: LCCN 2016057163 | ISBN 9781421594071 (hardback)
Subjects: LCSH: Comic books, strips, etc.--Authorship. | Comic books, strips,
 etc.--Technique. | Comic books, strips, etc.--Japan--Authorship. | Comic
 books, strips, etc.--Japan--Technique. | BISAC: COMICS & GRAPHIC NOVELS /
 Manga / General. | ART / Techniques / Cartooning. | LANGUAGE ARTS &
 DISCIPLINES / Composition & Creative Writing.
Classification: LCC PN6710 .A69 2017 | DDC 741.5/1--dc23
LC record available at https://lccn.loc.gov/2016057163

Printed in the U.S.A.

First printing, June 2017
Sixth printing, July 2022

CONTENTS

INTRODUCTION

Why I Am Writing This Book

My goal in writing this book is to guide you down the "royal road" to creating manga—or, to put it more simply: this is a how-to book.

Specifically, it's a manga how-to book, which one might assume has an audience limited to the scant few people who want to write and draw manga. After reading these pages, perhaps only a small number will become professional manga creators—*mangaka*—or maybe only one, or none at all. If I were to make a manga instead of writing this book, that manga would certainly find a far larger readership. And yet this is a book I want to write, if only for that one person.

That said, the royal road to creating manga is relevant to more than just manga. In one way or another, I believe this knowledge has universal applications. Much of the process of creating stories and characters for manga applies to novels and film, just as methods of drawing do to painting, and idea development generally can be useful in many other professions. The perspective from which fictional settings are constructed could also overlap with studies into social structures or science.

Because manga as a medium has developed as an amalgamation

of all these different fields, I'm always keeping my antennae tuned to those worlds. From that point of view, the royal road to manga should be taught universally, rather than merely to those who wish to create manga. This is first and foremost a book for those who want to become mangaka, but I also hope it will provide new avenues of thought to all who read it.

The Golden Way

Through my more than three decades of making manga, I've learned much by repeated trial and error. In this book, I will write about the knowledge I've gained about how to create a manga that adheres to the royal road, but this is just one snapshot of the progress of manga as an art form—what I call the "golden way"—which has existed invariably since long ago.

If you want to create manga, I hope that you will learn the royal road to manga and that you will pursue the golden way with awareness. The royal road to manga will lead you to creating works that will be beloved and thus passed down across the generations. Those who would be satisfied with a single, temporary hit—even if they end up striking upon several successes—will not truly understand the royal road to manga. As a word of advance warning: that attitude won't keep a mangaka going for long. Manga is not so lenient.

Follow the Royal Road, but Carry a Map

Another way of looking at the golden way is as a map to be used when you've lost your way. If you were to go hiking on an unfamiliar mountain, you'd bring a map, right? If you also have with you a foundation of mountaineering skills, like basic survival knowledge

and familiarity with mountainous terrain, you could wander onto side paths and discover unexpected scenery, and if you were to come across any dangers, you could find your way around them and still reach the summit.

But if you try to climb a mountain with no map and no fundamental knowledge, you will soon be wandering at random. Your chances of reaching the top will plummet, and you may leave the path never to find it again, or even end up stranded on the mountainside.

Think of the golden way of which I write in this book as signposts directing you to the royal road of manga at the summit. Attempts to reach those heights without any such map or anything else to guide the way will be frustrated far from the peak. This is something I've seen and heard happen many times.

I don't want aspiring mangaka to have to experience such a fate. Of course, I'm not saying that you have to create your manga in exactly the same ways I outline in this book, and some will probably read some of it thinking, "No, this part is wrong." But you can only understand that something is wrong if you know the way. In that sense, I hope that this book can be a map for those who want to create manga.

Never Lose Sight

I myself had several maps that got me through the difficult times before and during my early career, when I was struggling to gain readers' acceptance. One was a book of interviews by famed French New Wave director François Truffaut with the master of suspense, Alfred Hitchcock, titled *Hitchcock/Truffaut*. The book can be considered a textbook for filmmaking, but I also think it's a must-read for aspiring mangaka.

The tome, nearly four hundred pages long, provides a detailed account of Hitchcock's meticulous filmmaking process. Hitchcock freely reveals specific techniques, including how to foreshadow and set up a plot, and how to develop a character's psychological portrait. The interviews provide one revelation after another, and the book has been of indispensable value to me; I still read through it every now and again.

I was able to persist under the continued harsh criticisms of my editors without my spirit breaking because I had a clear goal—I knew what manga I wanted to create—and, because I had my maps, like *Hitchcock/Truffaut*, I could see the path I needed to take to get there.

The worst thing for aspiring mangaka is not knowing what kind of manga they want to create. When editors say that such-and-such part doesn't work, or the manga needs to be more like this or that, some new to the field ask their editors, "Well, what *should* I be making?" But that's the one question that absolutely should not be asked. Not knowing what one should create is like walking on a glassy smooth surface though total darkness. In a situation like that, not even a map would be of any use. So please, never lose sight of your purpose—of what you want to achieve by creating manga.

JoJo Is a Manga of the Royal Road

If I were to say that *JoJo's Bizarre Adventure*, currently on its eighth series, is a manga of the royal road, a good number of people might think, "What? Isn't *JoJo*…weird?"

It's true that when part one was first being serialized, *Shonen Jump*'s lineup was filled with the best of the best, from giants in the manga world like *Dragon Ball*, *Fist of the North Star*, *Captain Tsubasa*, *Ultimate Muscle*, and *Knights of the Zodiac*. And yes, I was often told

that *JoJo* was the odd duck.

But I believed in my manga, and that *JoJo* was a manga of the royal road, and I kept going. As for how I can say that *JoJo* is of the royal road, when at first glance the manga seems anything but normal, I will be offering concrete examples and explanations.

From a certain perspective, writing this book is like a magician revealing his tricks; in truth, some of what I will reveal are secrets that I'd be better off keeping. To be perfectly honest, by making public ideas and methodologies that are trade secrets, which up until now I've held under monopoly, the publishing of this book will be disadvantageous to me on a personal level. But I'm writing this book because my desire to impart these techniques is far greater than any disadvantage that may come from revealing them.

And thus, this book to repay the manga world. By passing on the knowledge I've learned of manga's royal road, it is my hope that I will in some part enable the creation of manga that is greater than what has come so far. If this book can somehow play a part in the future prosperity of manga, nothing would make me happier.

CHAPTER 1

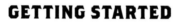

GETTING STARTED

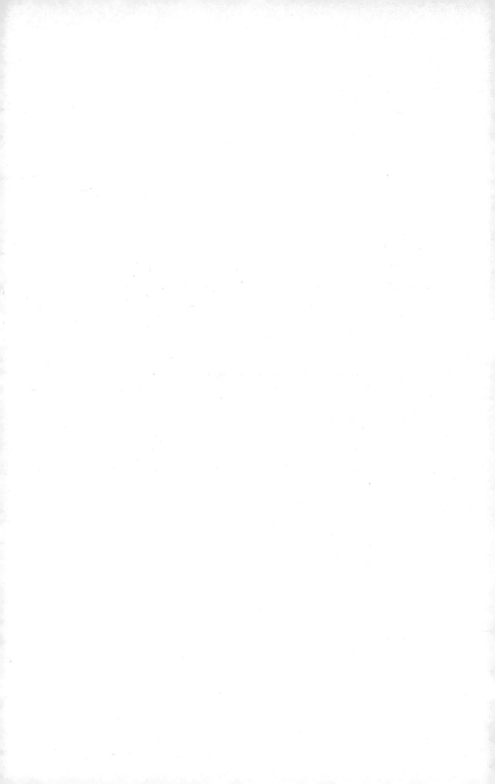

The Difference Between Yudetamago and Me

When I was growing up I loved manga, and eventually I decided I wanted to create it too. As my friends began to praise my work, drawing became more and more fun, and I started to think that I wanted to make manga for a living—to become a mangaka.

At the time, the only way for me to break into the industry was to win a competition in a shonen manga magazine—typically monthly or weekly periodicals that run manga, often serialized, targeted for a young male audience. Each year, when summer vacation came, I drew and submitted a new piece, but at best I saw my name among the finalists, never the winner, and of course I received no feedback from the editorial board.

The year I turned sixteen, a mangaka duo who went under the pen name Yudetamago made their professional debut with *Ultimate Muscle*. They were the same age as me, and the news gave me a jolt. I was at the age where I had to start thinking seriously about my future, and seeing their success made me go from thinking "I want to become a mangaka" to "I *will* become a mangaka." I began to give real thought toward why all my efforts were leading to rejections, and what made me different from Yudetamago.

Returned to the Envelope Unread

Although my rejected submissions have been lost to time, I know I tried to make them as special as I could. But thinking back on them now, I believe they failed because they were too unoriginal and were missing that something that could catch the editors' eyes. My drawing style imitated that of a manga I loved called *Babel II*, by Mitsuteru Yokoyama, only mine weren't good. To an editor who had to read dozens of submissions every day, mine must have evoked feelings of tedium from the very start—*Oh, another of these.*

When I entered the profession, a great many editors were the severe type. (And that might be true to this day.) They were not at all of the opinion that they should avoid saying anything that could harm a novice mangaka's pride, or that they should tread lightly so as not to hurt a newcomer's feelings. Rather, the editors treated the novices as the professionals they aspired to be and presented them with unsparing criticism. But it was because of them that I went from drawing only what I wanted to draw to realizing the path I needed to take.

When I first started making manga, my greatest fear was presenting a new work to the editorial team and having the editor partially slide it out of the envelope, then return it without even turning to the second page. It was all too common for an editor to see the very first panel and judge the work to be no good and not worth reading any further. I worried that if that happened to me, it might be a blow from which I would never recover.

Rejecting a work without even reading it may seem unnecessarily harsh, but those editors see a huge volume of submissions and have developed the ability to tell what the rest of a manga will be like from the first page alone—just as readers may look at a manga's cover and

decide that's all they need to see.

Even mangaka who had already made it into the profession could have their submissions rejected at the very first page and would leave their meetings in tears. Witnessing that kind of sight, while waiting for your own turn to go in and show your submission, will impress upon you the importance of creating a gripping first page. In essence, the very life or death of your manga will depend upon that first page.

Make Them Turn the First Page!

All right, so the first page is important. But how should you create it? Many elements can go into that first page—the drawings, the title, the protagonist's dialogue, and so on—but if the sum of the elements is something that feels unoriginal, something that someone else has already done, then neither editor nor reader will turn to the second page. Avoiding such an outcome is the first step.

That said, no one is going to come out and hand you a neat answer. How I found the solution was through systematically analyzing the first pages of popular manga. Since every mangaka takes special care with their first pages, I could study those leading pages to see what the creators were trying to achieve and the effects of their techniques, and use that knowledge to bring my own work alive.

One word of warning: studying best-selling publications is crucial to finding what elements sell, but you mustn't simply copy those works. That goes doubly as a newcomer who may not yet possess the drawing technique to make a copy that reaches the same quality as the original. No matter how popular the example manga is, you mustn't jump straight to the easy answer of simply mimicking the style and expecting your copy to sell. The idea is to gain a foundation of knowledge upon which you can search for your own creations.

Creating the First Page, Part One: What to Draw

When looking at the art itself, you might find certain elements that provide appeal, such as the following:

- Pretty art
- Unusual art
- Creepy art
- Clean lines
- Bright art (pleasant and airy)
- Sexy art
- Art portraying light
- Stylish art
- Purposefully inexpert art (art made as simply as possible)
- Art that has never been seen before
- Photorealistic art
- Comedic art
- Art with few motion lines
- Art featuring only women
- Art featuring only children
- Art featuring only stone and rocks

And many others…

By making a list like this, you can find elements to create a first page that readers will continue past. The next step is to figure out

what drawings you will make from them. Selecting the style for your first page requires the utmost care.

Creating the First Page, Part Two: Find a Compelling Title

The same applies for the title. If you look at Go Nagai's titles, for example—like *Shuten Dōji* and *Burai the Kid*—many of them involve wordplay. His puns couple with his unique style to draw in readers. Make a list of titles of some popular manga, think about which ones might inspire readers to turn to the next page based on title alone, and then think about what kinds of titles you'd want to use. You need not restrict titles to manga alone; including hit movie and novel titles may also be of help.

I'll include a short list of titles that come to mind. For any you haven't read (or watched), feel free to think about which pique your interest, and what makes them good titles.

- *Sazae-san (*The Wonderful World of Sazae-san*)*
- *Jurassic Park*
- *Kami no Tsuki (*Paper Moon*)*
- *Chibi Maruko-chan*
- *Bleach*
- *One Piece*
- *Sakigake!! Otokojuku (*Charge!! Man School*)*
- *Death Note*
- *Naruto*

And many others.

Jurassic Park (1993) is a wonderful title that encapsulates vivid imagery, and *Paper Moon* (2014) leaves a striking impression. The use of a single kanji (魁) for *Sakigake!!* is enough to clue in the potential reader that the manga will be about delinquents from the *yankii* subculture, and the addition of *Man School* hammers the image home. Together, it's a prime example of a title that conveys the content of the manga at a single look.

Personally, I've always taken a liking to titles that include the main character's name, like *Sazae-san* and *Chibi Maruko-chan*, even over "cooler" titles. Titles like that convey to me the impression that the authors care for their main characters. Because of this, I often include character names in my titles, such as *Mashonen Bī Tī* (Cool Shock BT), *Baō Raihōsha* (Baoh: The Visitor), and *Kishibe Rohan wa Ugokanai* (Thus Spoke Rohan Kishibe).

With *Cool Shock B.T.*, which became my first serialized manga, I put a lot of craft into the title to make sure the editors would take my submission out of its envelope. First, I used the word *Mashonen* (Devil Boy) to catch the reader's interest, then used the initials B.T., instead of a name, to allude to the way news reports refer to underage criminals in ways such as "Boy A," thereby creating an air of mystery and crime, so that the readers would recognize from the title alone that the manga belongs to the suspense genre.

I also included the main character's name in *JoJo's Bizarre Adventure*, but I could as well have gone with something like *Akira's Mysterious Adventures* or *Andy's Splendid Journeys*. But because the main character was a foreigner, and therefore something unfamiliar, I wanted to use a memorable nickname for the title. Then, by using the word *Bizarre*, the readers would understand that at least something about the world of the story would be unusual. For the last part of the title, I tested out many different words before deciding on *Adventure*.

Creating the First Page, Part Three: What Makes Good Dialogue

Now, make a list of what kinds of dialogue would make you want to read on to the next page. I'll provide some examples.

- Shocking dialogue
- Mellow, calming dialogue
- Comforting dialogue
- Sad dialogue
- Angry dialogue
- Joking dialogue
- Dialects
- Dialogue in haiku (5-7-5)
- Dialogue that rhymes (think rap)

And many others.

These are certainly not the only effective types of dialogue for a first page. Look at the dialogue on many manga's front pages and think about why they make you want to read further. When you think you have a feel for it, use that foundation to find your home-run opening lines.

When it comes time to draw your first page, you must do so purposefully, and only after thinking though every detail, based on your own analysis of successful works—from the art, to the title, to the dialogue—in order to capture the attention of your editors and your readers and to make them turn that first page. The beginning is far too important to draw without care.

The Five Ws and One H: The Foundation of the First Panel

When I began making manga as a hobby, I drew my first pages without giving them much thought. But as I continued analyzing other works, I began to understand the fundamentals of the first panel.

At the most basic level, the first panel should illustrate the five Ws and one H—in other words, who is doing what, and when and where, and why and how. As a natural result of establishing the main character's location and the time at which the scene takes place, the first panel will likely be somewhat large, and often a depiction of the hero with buildings in the background.

If you follow that pattern too closely, you will end up with a too-familiar panel at a too-familiar size, even if you do manage to check off the basic 5W1H requirements. Since you mustn't draw the same things as other artists, you need to find something uniquely yours to capture the reader's attention. It was from this line of thinking that I began devoting conscious effort to devising ways of throwing in curveballs without abandoning the fundamentals.

Since I enjoy suspense stories with mysteries to solve, I decided to apply those techniques in my manga. For example, I could start with a panel that leads the reader to question where the main character is, then gradually pull back the viewpoint to reveal he's locked up in a hospital. As with the other elements of the first page, so too must you come up with a solution for the five Ws and one H that is a little bit different than manga that have come before, and in doing so invite the reader's interest.

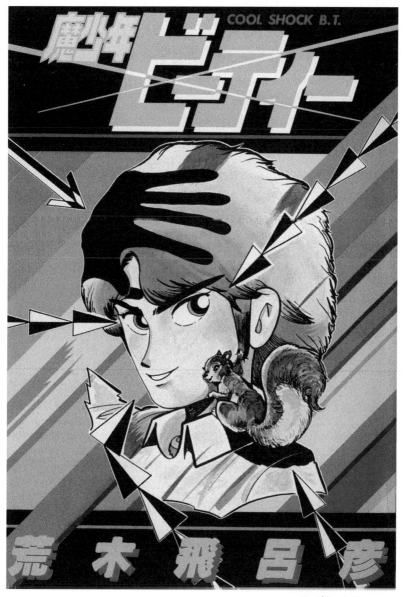

COOL SHOCK B.T.

Cool Shock B.T. cover

Offer Many Pieces of Information Simultaneously

The next skill I worked to acquire was how to serve many goals in a single drawing.

Let me give a single line of dialogue as an example:

"I think I'll make pasta tonight."

From this sentence, I can communicate a range of information about this character to the reader:

- The character likes Italian food
- The character does their own cooking
- The character likely lives alone, and not with a family or significant other
- The character does not live in utter poverty

This dialogue can work in conjunction with the character's hairstyle and clothing to convey much of the protagonist's circumstances and personality in a single glance. Drawing a unique kitchen as the background would instantly tell the reader that something was different about this character.

The same applies to the cover image as well. In the cover page for the first chapter of my first serialized manga, *Cool Shock B.T.* (the image was also used for the graphic novel), I drew a bust of the main character, B.T., and I also included several mechanisms to capture the readers' interest.

- The series of black and white arrows establish a recurring design
- The shadow of a hand falling on his head suggests mystery and suspense

- The colors and shapes of the background present a modernistic feel
- The squirrel perched on his shoulder symbolizes friendship

In this manner, a single drawing and a single line of dialogue can communicate the main character's personality and circumstances and will leave a strong impression on the reader within one panel. Manga's unique strength is the ability to express in a single image what a novel might expend many pages on. This is an important point to keep in mind.

A Manga's First Page Is Its Preview

I always draw a manga's first page in a way that serves as a preview of the pages to come.

For example, if I were making a manga about a war, I could depict an emotional scene with the soldier and their family, or possibly establish that the theme is antiwar, or even simply start with a battle scene. Readers want to quickly grasp what kind of manga it is that they're reading—where the manga is headed, in other words—and if too many panels go by without them being clued in, they'll decide they've read enough.

I like to answer the 5W1H in the first panel, and in the second present the main character doing something a little unusual to suggest that my manga is not like every other. Communicating distinctly and dynamically to readers what they're about to read requires great skill, but it must be done in order to make them want to keep reading.

To illustrate using my previous example of the man who in

panel one said, "I think I'll make pasta tonight," I could draw the second panel to show him saying, "I guess I'll go to the wheat field," and heading for the door. The reader, presented with this surprise, would think, *Wait, he's not starting by boiling the pasta, but instead by going to harvest the raw ingredients and then making it by hand? This guy might be interesting.* The reader will naturally want to turn to the following pages to find out what this clearly unconventional character will do next.

The opening of the first *JoJo* manga also serves as a preview for the manga to come. Partly because I wanted to try my hand at an adventure manga for *Shonen Jump*, I decided not to start with the main character's introduction, but with a prologue scene involving the stone mask, an Aztecan treasure. But even though I eschewed the standard rules for how a manga should open, I made sure to communicate the mood of legends and ancient oddities. I wanted the readers to know that the stone mask and its powers would drive the story forward.

Seize Unclaimed Territory

As a result of studying popular manga and analyzing what I had been doing wrong, I was able to make my professional debut with *Busō Poker* (Poker Under Arms). *Shonen Jump* selected the story as a second-place winner—first place was not awarded at all that year—for their Tezuka Award for up-and-coming mangaka in 1980; I had finally taken my first step into the world of professional manga creators.

When I set out to make *Poker Under Arms*, my first thought was that in order to get the editors to read my work, I needed to claim territory no other artist was drawing. To that end, I chose to make a western.

I've always loved westerns and stories in desert settings. I had been captivated by *Babel II*'s uniformed schoolboy going alone into the desert. The image of the main character striving to be the best he could be, amid the vast and lonesome desert, was a beautiful sight, and I thought it was cool. It resonated with the image of the great Clint Eastwood riding his horse across the wilderness and drifting on to the next town.

At the time, the only other shonen manga in a western setting was *Kōya no Shonen Isamu* (Isam—Go into the Wild West) a manga drawn by Noboru Kawasaki about the child of a Japanese man and a Native American woman. Because of this, I thought I could utilize a western setting to stand out from my peers.

Poker Under Arms: Draw Your First Page Like This!

Now, let's look at how I drew the first page of my first published manga, *Poker Under Arms*.

But first, let me back up and start with the title page. The straightforward approach to a manga's cover or title page is to draw the main character, but *Poker Under Arms* was to be an atypical manga, a western, and one involving a card game battle. Instead of the customary main character, I came up with a composition where the largest element was the legs of a man (with his face hidden) who had been shot and was falling over backward. I put the faces of the two poker-playing gunmen on the playing cards on either side.

I figured that the other applicants would draw their characters looking cool, or with attractive women, and I purposefully did something different for my attempt at the Tezuka Award. I also chose a title that would evoke an image of violence and gaming.

As for that all-important first page, I scattered several nonstandard

elements throughout. Where the main character should typically appear, I instead brought forth a narrator who is revealed as the culprit at the end of the tale. He's a middle-aged man, well-built and wearing a suit, and he says, "This is a tale of two gunmen" and "It's a true story, witnessed by my own eyes." Starting with a narrator, as with Watson in the Sherlock Holmes series, is an incredibly effective technique in suspense stories.

The western background in my first panel is there to provide part of the typical 5W1H. Standing in frame is the narrator, for some reason standing alone while drinking wine beside a picnic table. My intention was to present a mystery to the reader: *Why is this man drinking wine there? Who is this man, anyway?* Meanwhile, I slowly pull back the perspective from a close-up to a long shot for a cinematic feel.

The main character first appears where the story begins, on the second page. I needed to quickly establish what kind of character the gunman was. To do so, I came up with a scene in a barbershop, where an enemy attacks the main character midshave. I made the main character a villain with a high bounty on his head, whose life is in constant danger from bounty hunters. I thought that by showing him taking care of his appearance at a barber shop, even amid such peril, that I would create a tough-guy image for the character. At the same time, by showing someone get killed within such an everyday situation, I hoped to impress upon the reader that this was not a typical place.

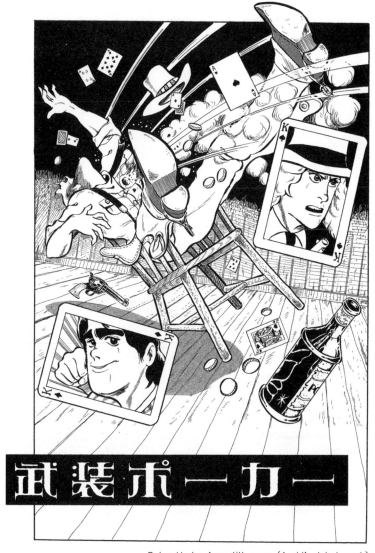

Poker Under Arms title page (Araki's debut work)

NOTE
Pages in this book are ordered in the Western mode, left to right. Read individual pages starting at the top right and ending on the bottom left.

READ THIS WAY

Poker Under Arms

1

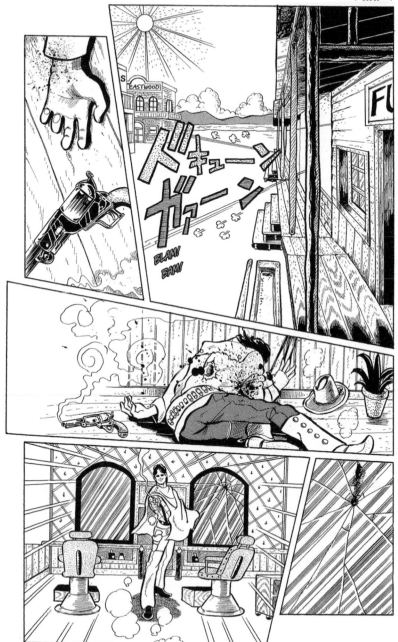

2

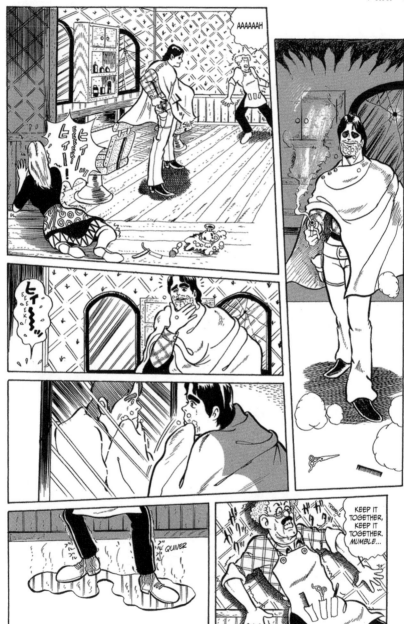

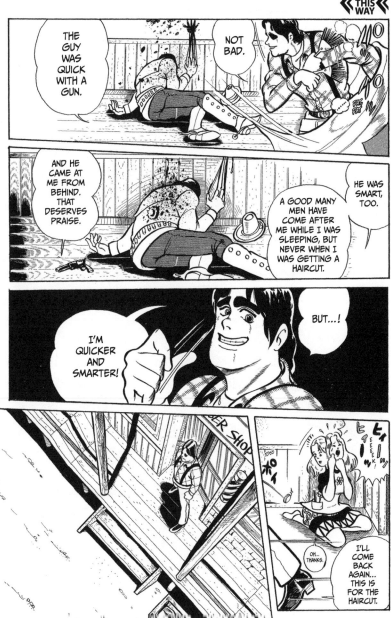

4

How to Make Them Read to the End

My primary goal with *Poker Under Arms* was to get the editors to read my work to the last page. I drew each panel deliberately, so that each served a clear purpose, and no single image remained that could be removed, but I focused most of my efforts on the opening pages. I made sure to include all the required elements: the fundamental five Ws and one H, an individuality of my own, achieving multiple goals in the same drawing, and offering a preview of the coming pages. It was the best work I'd produced up to that point, and polished to a level that would challenge any editor to find fault with it.

I made my professional debut with *Poker Under Arms*, but that didn't mean I was immediately transformed into a proper mangaka. Rather, the perspective of the *Shonen Jump* editors was more like, "Well, we'll give him a shot." To them, I'd only arrived at the starting point. Over the next several years, as I searched for that next step, I created stacks and stacks of rough panel layouts—I think about five hundred pages were rejected. But through this learning process, I eventually came to understand what elements a manga needed to make the editors and readers keep reading to the very end.

I call them the four major fundamentals of manga structure. They serve as my guideposts to creating a manga of the royal road, and I'll explain them in the next chapter.

CHAPTER 2

MASTERING THE FOUR MAJOR FUNDAMENTALS OF MANGA STRUCTURE

The Four Major Fundamentals of Manga Structure

When it comes time to create your manga, you should always have in your mind a diagram I call the four major fundamentals of manga structure.

In order of importance, they are:

- Characters
- Story
- Setting
- Themes

These four elements are not independent, but rather they deeply, mutually influence one another. Your art is then your ultimate tool to expand and unify these elements, aided by your dialogue.

In other words, what your readers will see is the artwork, but behind those drawings exist the interconnected elements of characters, story, setting, and theme. This structure provides the makeup of an entire world, or even a universe.

I believe that manga is the most powerful multidisciplinary art form because it is capable of simultaneously expressing the four

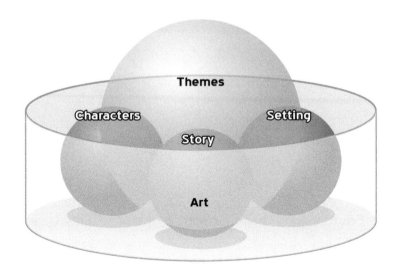

The Four Major Fundamentals of Manga Structure

major fundamentals *and* art *and* writing. A creative person without the ability to draw can become an author or scriptwriter, and one without the ability to write can become a painter. But a mangaka must be able to do everything.

When creating a manga, it is incredibly important not to simply draw on a whim, but to be conscious of the four fundamental elements as you draw. *Am I making good characters? Is my story acceptable? Am I drawing a coherent setting? Are my themes consistent and steady? Are my drawings good enough?* If you maintain a constant watch on these sorts of issues—as your editors will likely do as they read your work—you will recognize where your work needs improvement; for example, *I'm not getting my characters across, so I might lose the readers.* A majority of works that fail to capture their readers have problems with their characters; if you can recognize it when it happens in your manga, you can think of how to correct it.

Characters and Setting Are Indispensable

It is possible for a manga to succeed based on characters or setting alone. Some professional mangaka believe that manga doesn't need a story at all, and I have to agree that, although it would be an extreme case, a manga without a story can be done.

Prime examples of manga that center on characters rather than plot are *The Wonderful World of Sazae-san* and *Kochira Katsushika-ku Kameari Kōen Mae Hashutsujo* (This Is the Police Box in Front of Kameari Park in Katsushika Ward), often shortened as *Kochikame*, which don't contain anything that could really be called a story. The scenes of Sazae-san and her family, and of Ryo-san and *Kochikame's* cast of regulars, feel more like a sketchbook diary, and their manga are powered by characters' actions and personalities alone.

Of manga that succeed thanks their world building, the most representative example is *Akira*, which is set in the Tokyo of the near future, where boys awakened to supernatural powers battle in a post-apocalyptic world. It's a wonderful work and truly a masterpiece; although published in a serial format from the 1980s into the '90s, it retains the power to draw readers of today into its world. I would add *Cobra the Space Pirate* as a manga that I believe sets out to create a spectacle, as many Hollywood movies do. The tough and cool lead character is a part of the setting, and the plots and the characters' inner workings are given comparatively less importance.

A more current example would be *Mushishi*, which I consider a quintessential example of a manga that depicts an unseen world. The manga is set in a fictional time between the Edo and Meiji periods, and has a main character named Ginko, who is a Mushishi (a master of "mushi," invisible creatures with supernatural powers). The manga portrays various incidents brought about by these mushi. What I find

remarkable about this manga is that, despite not having incredibly appealing characters or story, the author's depictions of these natural and spiritual entities, and the mood she invokes with them, grab on to the readers and never let go. It's an unusual series, and one that gives me the sense that the author was focused on creating the setting. Even the kanji selected for the title—蟲師, which are obscure and hint at the primordial—serve to heighten the mood.

Balance the Four Elements

As you can see, it is certainly possible to create a manga that focuses on one of the four fundamental elements. There's nothing unusual about a manga lacking in story becoming a smash hit based on the appeal its characters hold, while some manga focus entirely on their stories, and others on their settings. The goals of each work are up to each mangaka, as is how to convey them through drawings.

But manga with one element that drastically stands out from the rest will always be limited in some way. To overcome that limit, the other elements are needed.

In order to create a manga that will become a classic read across generations, the balance between the four fundamentals is incredibly important. If you examine works that are currently considered masterpieces, you'll see that the four major fundamentals of manga structure are all in order. Even if your goal requires focus on a single element, you must remain mindful that you are still keeping a balance.

Making a Habit of Analyzing Best Sellers

Not only when you are reading manga, but when you are reading

novels or watching movies as well, instead of just thinking, "Oh, this is interesting," you should instead analyze why it is interesting, especially with regard to the four fundamentals.

Let's take *Kodoku no Gourmet* (Solitary Gourmet) as an example and compare it to our diagram. Its main character is called Gorō Inogashira, and the manga is about nothing more than what he eats. The setting is that of so-called "B-class gourmet"—down-to-earth local eateries—and Gorō is a distinctive character.

At first glance, story seems to be absent, but a battle-like tension between the man and the menu provides suspense over what food will come out. Besides that, by starting with an appetizer and ending with a dessert, the meals themselves follow a basic story structure.

Gorō follows a consistent philosophy of enjoying meals alone, and that forms the manga's theme. The author leads the reader to believe the character might go in search of romance, but no, he only goes in search of food. To Gorō, an empty stomach is a more pressing concern than romance, and really, that might be true for all of us. And when a person's stomach is empty, they are alone. Through that lens, Gorō Inogashira is a perfect portrait of the human condition. *Solitary Gourmet* can be considered a masterpiece of food manga.

As for the drawing, which brings the four fundamentals together, Gorō is drawn as an everyday salaryman, but the food is drawn with complete realism. *Solitary Gourmet's* mangaka, Jiro Taniguchi, is one of the best artists—and maybe *the* best—at drawing in ultrarealism. Without a mangaka who was able to draw the food right, the manga might never have been able to hold up.

There may be some works out there that are more popular than you feel they deserve to be. I suggest you hold those up against the four fundamental elements. If you do, you may recognize that, for example, the characters and the story are lacking but the setting is

superb, and that must be what has struck a chord with the audience. I am constantly analyzing works in this way, and if you get in the habit of doing it as well, you'll begin to understand what you need to do to create manga that many people will want to read.

Over the next several chapters, I'll go in-depth on each of the four fundamental elements.

CHAPTER 3

DESIGNING CHARACTERS

The Golden Way to Making Protagonists

Of the four fundamentals, characters are supreme: if you have effective characters in place, you will be undefeatable. Taken to the extreme, this means that compelling characters negate the need for story or setting. That's how incredibly important they are. Some mangaka will go as far as to say that if you have characters, you have a manga.

Here's a little quiz. I'm going to describe a character. He has an honest heart; when faced with a situation where others would lose spirit, he remains optimistic and overcomes the challenge. He has a sense of justice, cares for his friends, and is a master of martial arts. His signature technique is the Kamehameha.

By now, I'm sure you know I'm talking about Goku. Take this simple character, perfectly suited for a shonen manga, and pair it with Akira Toriyama's art, and you get *Dragon Ball*.

Here's another example. He slacks off at work and cares only for his own pastimes, but he has a razor-sharp focus and never goes halfway. He's a policeman in a working-class part of Tokyo.

That this is recognizable as Ryo-san is testament to *Kochikame*'s position as a masterwork. That such a short, basic description can call the character to mind may seem like no big deal, but it is, and a huge

deal at that. All the author has to do is come up with a situation for Ryo-san, and that's enough to write the next chapter. (Not to trivialize the difficulty of keeping it up for forty years…)

But you mustn't simply copy another character, no matter how quintessential that character may be. For example, I'll base a character on Goku: an optimistic youth who cares for his friends, never gets discouraged no matter how big or small the challenge, and is a kickboxer with a signature move called the *kōsenkeri* (light beam kick). This is not a character that will appeal to readers, because Goku already exists as an established character, and no rehash will ever seem fresh. But that leaves an obvious question. How can you make an appealing character without imitating another?

What Does Your Character Want to Do?

Once you've been convinced that characters are incredibly important, and that you mustn't imitate established characters, the next step—before you begin drawing—is to form a mental image of your characters, with all the necessary pieces in place.

The most important part of a character is their motivation. What does your protagonist want to accomplish? If you can't clearly communicate their motives through their actions, he or she is not a complete character. It's crucial that you be able to illustrate why your characters act the way they do. If you leave your characters' motives vague, your readers won't be able empathize with them. Returning to *Dragon Ball's* Goku as an example, his motivation is to become stronger and stronger. It's a simple motivation that's easy to understand, and has been shared by every boy, which then makes room for deeper examination: Why does he want to become stronger? What will he do when he does? Because of this, readers can connect with

the character and share in the emotional highs and lows.

When it comes to creating characters, it may seem natural to begin with their personalities, but you have to be able to show the readers within the first or maybe second page what purpose that character possesses for being in the story. If your main character is a superhero, start by considering why the character became a superhero. If the character starts acting like a superhero without having a clear motive, the readers' first reaction will be, "What the hell is this character doing?" and they won't come along for the story.

The motivation could be anything. His parents were killed by evildoers. He wants to get a woman. She has a fatal and incurable disease, and as she's going to die anyway, she might as well die a hero. Or even simply that she was bored. As you keep thinking of possible motivations, you're looking for the one that feels the strongest and most interesting to you.

What Makes a Good Motivation

Your characters' motivations have to gain the interest and empathy of your readers. A good motivation is one that makes the reader wonder what will happen to that character, and what that character will do, because then the reader will want to keep reading.

What you have to realize, in the instance of shonen manga magazines, is that those motivations will always be attuned with the readers' natural sense of ethics. The three principles of *Shonen Jump* are friendship, effort, and victory. Likewise, shonen manga readers will strongly empathize with what they feel is good and right, and will reject that which they feel is unethical. Because of this, characters such as *Death Note*'s Light Yagami, who kills again and again—even if the targets of his assassinations are criminals themselves—require

skillful technique for the mangaka to win over the readers. On the reverse side, characters who are 100 percent virtuous can come across as fake and unlikable. To avoid this, you need to include in your main characters weaknesses or faults, or more human desires.

Even if your main character's motives are well-defined, cowardly acts will still repulse your readers. This is mostly because cowardice is in direct opposition to the morality of your audience. Readers will never empathize with a gutless hero who sacrifices innocent bystanders to save his own life. Similarly, if your protagonist is in a tough situation because he blundered into it, your readers will judge the character as a fool and will only react with antipathy.

Make a List of Motivations

As an exercise, let's make a list of motivations that might evoke a reader's empathy and interest.

- Self-protection (of social status or prestige; feelings or memories; suppressing a scandal, hiding evidence of a crime)
- To protect a loved one (family or lover, friend, etc.)
- Work, duty, or patriotism
- Curiosity (a mangaka looking for story ideas; a collector; self-discovery)
- Vengeance (a passionate desire for revenge will evoke empathy)
- Desires (for money, sex, love, power, etc.)
- Pursuit of happiness (freedom of expression, political

freedom, to become strong, to meet a hero, to make others laugh, to find something that is missing, etc.)

And many others…

Beyond these, some motivations may pique a reader's interest even if they're not shared or understood, like wanting to collect women's hair or underwear.

If you want to become a mangaka, I recommend you create a list of motivations. Not only will it be useful when you go to create a character, it also may lead you to discover new motivations. To take an example from *Thermæ Romæ*, the desire to build a nice bath was a never-before-used, unique, yet eminently relatable motivation that ties into human life and history.

Bravery Begets Empathy

Readers will most strongly empathize with motivations such as those listed above when your characters face their obstacles with bravery. Take that ultimate dilemma of a hero having to choose between either saving a child or a friend. Situations such as that present the best opportunity for a main character to display their bravery.

I often have my characters display their bravery in my stories. In a similar dilemma in *JoJo*'s seventh story arc, *Steel Ball Run*, the villain, President Valentine, under attack by the hero Johnny's Stand, begs Johnny to let him go and offers to bring back Johnny's dead friend from another dimension. Johnny struggles with the choice—whether he should bring his friend back to life or defeat his enemy. Readers are drawn in by the suspense; they want to see how he will overcome this dilemma, and they will keep turning the pages in anticipation.

Basic Human Desires as Motivations

If you create a list of motivations, you'll probably notice that almost all stem from basic human desires. But keep in mind that, as I said above, in order to gain the empathy of your readers, you need agreeable motivations that conform to their natural sense of ethics. For example, if the motivation is a desire for wealth, you need to work it so that rather that being a simple robber, the character needs money in order to save someone else.

Readers will be able to root for your main character's search for vengeance, despite it being an antisocial motivation, when the goal is to take out an evil that is beyond the reach of laws or the authorities. The period drama television series *Hissatsu* (Sure Death) provides a good example. The main characters are hired killers of bad people, and when the viewers begin to accept that their targets are so bad that getting the law involved just isn't necessary, the assassins take on the role of justice, and the audience becomes able to cheer them on. But if the viewers are ever given room to think, "Why not just go to the police? They're being selfish," then revenge will fall apart as a motivation.

Infidelity is also antisocial, but if you depict it not as just a raw sexual desire, but as something that is wrong but a relatable temptation, readers will think, "Yeah, that's how it is. But this isn't going to end well for the two of them." The emotional connection will bring readers closer to the characters. A good example of this can be found in the movie *Unfaithful* (2002), where Diane Lane's character commits adultery.

The Allure of Evil Characters

On the other hand, humans aren't always pure and good, but carry an ugly side within themselves. It's just that in normal life, morals, laws, and other rules of the world keep those baser natures from display. When an evil character freely exhibits those normally hidden desires and acts in a way the readers could not, the readers can find great catharsis. In the first story arc of *JoJo*, I always intended to make Dio look cool as he charged headlong down the villain's path, but I think it's due to that catharsis that some readers took to the character with incredible zeal.

By providing an outlet for the ugly feelings that we all share, you can depict a more lifelike range of emotions than those of only goodness, and in doing so, you can more effectively evoke readers' empathy. If you can create a truly evil character, your manga will be more likely to become a classic.

That said, being able to get readers to empathize with ugly desires is a tremendously tall hurdle, one that requires thought and planning to overcome. Once you have that ability, you could turn even a heartless killer into your main character.

In Dio's case, I depicted him as coming from an unfortunate upbringing, saddled with a father who had no redeeming qualities whatsoever. I gave him a background that could explain his hunger for power and his willingness to become evil incarnate to obtain it. Dio wanted to get revenge upon the world for his terrible lot in life, even if it meant taking an evil path and committing deeds contrary to morality and law. In the end, I think readers were able to accept that.

Contrast the Hero and the Villain

No matter how compelling Dio was as an embodiment of evil, the protagonist of *JoJo*'s first story arc was not him but rather the just Jonathan. Similarly, your main character must be fundamentally virtuous—on the side of justice (what "justice" is can be left up to personal interpretation), true to their friends, and brave. These three qualities are to me the most beautiful manifestations of the human spirit, and the overwhelming majority of readers will empathize with and root for virtuous protagonists.

If you set out to create an antagonist that is an opposite to the main character, like Mitsuru Hanagata versus Hyuuma Hoshi in *Kyojin no Hoshi* (Star of the Giants), the contrast between good and evil will be made more vivid. With Jonathan and Dio, I based the characters off the duality between light and shadow, and used black and white contrasts in my drawing to set them apart.

But sometimes the difference between good and evil may depend on your readers' viewpoints. As I've grown older, I've found that good and evil are not so easily delineated, and I've taken more interest in the reasons why people do bad things.

In the *JoJo* arc *Steel Ball Run*, the major villain is the deeply patriotic President Valentine, and from that perspective his stated goals may be more just—in fact, I suspect his intentions line up with those of our real-world leaders. But he's willing to sacrifice powerless people to achieve just ends, and that part of his character is, to the minds of the protagonist and the reader, unquestionably and unforgivably evil. Because of this, the character of President Valentine could never be the protagonist. I think this also serves as a good example of a point I made earlier—that readers won't empathize with a coward.

Heroes Fight Alone

A protagonist must not only be virtuous, but a hero as well. And if there's one criterion for a hero, it's being alone.

When a protagonist is faced with an ultimate dilemma, it must be one that only the protagonist can solve, and the protagonist must solve it with their own abilities—which again, in essence, means being alone. In *JoJo*'s fifth story arc, *Vento Aureo*, the Buccellati gang acts with a unified goal, but they are a collection of outcasts. Their connection is not that of a leader and followers or of a brotherhood, and when they fight, they each stand on their own.

There may be nothing more beautiful than a person who pursues something important, regardless of society's approval, and even if it means standing alone. The best heroes are like Jesus Christ; they may be praised by some, but they act not for personal gain and risk death in desolation and solitude, and they follow the call of truth within themselves. Those are the heroes.

Clint Eastwood's leading roles embody this image of a hero. My father took me to see my first Eastwood film—*The Good, the Bad, and the Ugly* (1967)—when I was in elementary school, and that image has remained unchanged ever since, through *Dirty Harry* (1971), *Unforgiven* (1992), and *Gran Torino* (2008).

Fundamentally, characters who cannot fight without the aid of another can't be considered heroes. When an audience sees someone dragging others into a fight, they can't help but think, "Hey, don't rely on others—do it yourself!" Even when allies are present, when it comes to the fight, heroes have no one else to rely upon. Otherwise, they don't have what it takes to be heroes.

Of my characters, the one who most markedly reflects the ideal heroes of Eastwood's roles is Jotaro Kujo of *JoJo*'s third arc, *Stardust*

Crusaders. Just in the way he stands, Eastwood projects a commanding presence backed by intelligence and discipline. As a character based on that image, so too does Jotaro pose an intimidating figure just by standing with his hand in his pocket.

The Difference Between Drawing Men and Women

Nowadays, both men and women can become heroes. Up until around the 1980s, male characters had to be dynamic and take action, and female characters had to be delicate and passive. But now, that's no longer necessary.

I think this reflects a greater cultural shift. Macho women became permissible in movies, like Linda Hamilton in *Terminator 2* (1991), and audiences began accepting women who could take punches, and even keep on fighting after being thrown over the edge of a cliff. In *JoJo*'s sixth arc, *Stone Ocean*, I created a female protagonist named Jolyne, and the only difference in the way I handled her as opposed to a male protagonist was not to draw her quite as beaten up—but she faces battles every bit as brutal as the male characters who came before.

Presently, if anything sets apart male and female characters, it's only visual. This holds true for me as well—when I create new characters, I don't pay any attention to differences between men and women, aside from possibly setting them apart through clothing or makeup, or sometimes including observations based on women around me, like when I've wondered *How long is she going to dry her hair?* or *What is she doing in the bath for an entire hour?*

If there's no difference between male and female characters, you may be wondering how to decide when to use a female character. It's purely a matter of your own taste. Take Yasuho Hirose, from *JoJo*'s

eighth arc, *JoJolion*, whom I made as a variation on Koichi Hirose from the fourth arc, *Diamond Is Unbreakable*. Koichi represented friendship, but I wanted to add romance to *JoJolion*, so I made the character a woman. I included many other female characters in *JoJolion*, but that was because I wanted to include elements of eroticism. I thought that with the relationship between the protagonist Josuke and Yasuho, I wouldn't be able to avoid such scenes, and I also wanted to challenge myself by attempting elements from genres I hadn't yet done for *Shonen Jump*. It even led me to draw bare breasts for the first time in my manga.

If it doesn't matter if a character is female or not, some artists think that adding a woman might create an element of charm, and therefore gain more popularity, but I'm not so sure I agree. I think that even if you're creating a manga that includes love and romance, you could have it be between two male characters, as long as that fits with your manga's world. As long as your characters are appealing, you could get away with a world of all men. You have nothing to fear.

Character Histories: The Secret Ingredient

When I'm creating a new character, before I do any drawing, I always write a character history. I have done so for over forty years, since before *JoJo* appeared in print—to me, it's something akin to a chef's secret seasoning. It protects against inconsistencies in the character— for example, if a character is established as being unathletic, but in a fight he is suddenly nimble.

It's like how you can look at a person's résumé and see a gap between the years that causes you to wonder what that person was doing during that time, or how a wedding's seating chart can tell you much about the couple and their families—*Why do these relatives*

Character
History

Name / Nicknames				Age	
				Sex	

Birthdate / Birth sign		Blood type		Birth- place	

Height		Weight		Hair color Eye color	

Eyesight / Colorblindness Wears glasses?		Handed- ness		Type of Voice	

History of surgeries Cavities / Illnesses					
Scars, Burns / Skin damage Birthmarks, Tattoos					
Other distinctive physical characteristics	Nose & eye shape, posture, breast size, legs, moles			Race	Reli- gion

Criminal record / Awards / Education	
Formative experiences as an infant / young child (including who involved)	
Sexual history / Lovers Thoughts toward romance / Married?	
People the subject looks up to / People the subject hates	

Dreams for the future	
Fears	
Personality traits favorite sayings, habits	

Relationships (incl. behavior)	
Family relationships (incl. behavior)	
Problem relationships	

Employment / School			Economic Status/Behavior		Pets / Plants	
Personality	Cheerful/Gloomy? Humorous/Violent? Active? Sociable? Intellectual? Virtuous? Expressive? Weaknesses / Worries / Unusual Traits	What is distinctive about them				
Special Skills Fighting Styles (Abilities)	Nimble? Sports / Dance Martial arts, guns Driving Language study / other certifications	Strengths and Weaknesses				
Hobbies Recreations (Likes Dislikes) (Food Clothing Shelter) (Habits) Favorite Phrases	Music / Newspapers Books / Magazines Movies Creative Pursuits Collections Favorite / Least favorite color Perfume / Cologne Décor / Fashion Location People Favorite stores, brands Favorite things Wears necklace, rings? Tastes / Drugs	Habits / passions Meaningless things				
Others	Wine / Food Supernatural abilities, attuned to spirits? Fortunes Accent / dialect Sixth sense for certain things, etc.					

have different surnames? Or, *I didn't know they had that many siblings.* Or, *The bride and groom sides are really unbalanced.*

In a similar way, writing a character history can help you visualize a character's intangible traits. It's critical that your readers understand your characters at a single glance, and as you write a character history, you will naturally form an image of how that character should be drawn. It may lead you to the story, too. For example, when you come up with an answer to the "fears" section, you'll have a basis for a horror manga story.

I got the idea to create these character histories from hearing about preparations Hollywood actors do for their roles. An actor playing the part of a police officer might go to a police academy and learn how to move and act like a real professional. The audience can tell in an instant whether something feels natural or not, and actors must strive to avoid giving performances that will shatter the suspension of disbelief. But when the details come across as real, they become a powerful tool to bring the role to life.

With manga, if your editors have to ask you what a character is supposed to be, you haven't properly conveyed the character. To avoid this, you must have a sufficient grasp of the character for yourself. Some elements of mystery are of course acceptable, but you must have a thorough understanding of what kind of person the character is.

Sixty Facts to Flesh Out Your Characters

Not everything in a character's history sheet will end up on the pages of my manga, but it serves as a necessary base to determine how characters will react to the situations in which I place them.

My character histories include roughly sixty entries that cover a

wide range of topics. I used a typical résumé as a template to which I've kept adding additional topics as needed to flesh out my characters.

I start with a name, age, and gender, followed by some basics which will be necessary when it comes time to draw them, such as height and weight. Other subjects, like birth date and blood type, may seem of little importance, but can help form an image of the characters' traits—born in the summer, so maybe they like the sea; they're blood type A, so they're probably fastidious. I also always include a history of education. A character of poor learning might be a good source of gag humor, while a smart character presents a different set of options—I could play up a showy and arrogant side, or present an opportunity to put their cleverness to effect.

I find favorite music to be indispensable when describing a character's traits, and whether or not a character has any pets—A dog? A lizard?—and how they treats their pets can affect a character's personality and outlook on life. Whom the character admires is also important. If someone idolizes Clint Eastwood, and wants to be Clint Eastwood, that person might start wearing the same expressions. A character's relationship with their mother and father makes for another vital element for determining their personality.

In order to answer all these questions, you need to have the knowledge and ideas to match. Matters unfamiliar to you personally can be studied by observing those around you, or even by reading books on medical science and psychology—*parents who act like* this *might have a child who ends up like* that. You should always write down ideas as they come to you, and of any conversations that make your ears perk up. That way, you can look it up later. You have to put in the work.

Special Abilities and Finishing Moves: The Origins of Stands

When I'm writing *JoJo*, I'll often think of a character's Stand—a personification of supernatural abilities common in the *JoJo* setting—before anything else, which means the first items I fill out on the history sheet will be that character's special moves and abilities. Let's say I think of a character who can stop time. I'll start there, and see where that leads me. *Do they need to be muscular to stop time? What about their appearance—is there a kind of hairstyle that might have something to do with time? How would their relationship with time be reflected in the décor of their room?* And so on. Some characters are primarily in the manga to fight, and in those cases, past wounds and surgical history become important entries that can suggest weaknesses they may or may not try to protect.

As I fill in the gaps on a character's history sheet, appearance, hairstyle, and clothing become inseparable from personality, and by the end I can draw a character who is recognizable from silhouette alone.

I also have to consider what form a Stand will take, and I'll consider absolutely any inspiration when finding a form that will match its powers. Sometimes it may be a familiar everyday object, like a coffee cup. For a villain, I might turn to something that will provide a mood of the spiritual or unfamiliar, like African folk crafts.

By the time I've added all the details, I end up being deeply attached to my characters. I've even cried when some have died. As an author, I should probably be less emotional, but I can't help but feel affection for characters whom I've put my heart into creating.

Characters Can Change and Be Erased

After you begin writing and drawing a character for real, you may notice something you want to change. If that happens, you can go back and revise the history sheet, and of course, if your drawing isn't coming out the way you pictured it, you can always make changes.

You will also inevitably run into dead ends during the character history step. If you determine that a character is not going to be someone you can use, you can make a clean break. Doing so only means the birth of a new character.

If you have a large cast of characters, you may think it tedious to create history sheets for each and every one of them, but it's those sheets that will keep you from just going through the motions. If creating characters becomes rote, your manga may very well become rote too, and your readers will think you only make one kind of character. Without character histories, you could fall into a pattern, and that could be your end.

Make a Sample Based on Yourself and Your Friends

If you want to become a mangaka, then creating character histories is another skill you need to practice. Before making a sheet for your characters, try making some based on:

- Yourself
- Your friends, acquaintances, and family
- Your heroes

Let's say you're doing one on yourself. This calls for some self-inspection that you're probably not used to doing. *What kind of*

person am I? What do I like? What do I fear? And so on. But as you fill in each blank, a character should begin to form.

During this process, you must make sure you list weaknesses and not only strengths.

When you're creating a sheet on a personal hero, you may only be able to think of positives and it might be difficult to think about any flaws or petty foibles. But by thinking of both the traits to which you aspire along with that person's weaknesses, you'll create a three-dimensional character.

Those weaknesses lead to distress, which your character will make efforts to overcome.

The most important part of making a character is to leave them room to grow. By depicting your character's efforts, you are depicting them growing as a person. This carries over into the story, but I'll cover that in the next chapter.

How to Differentiate Your Characters

When you first try making characters with this method, the first two or three will likely come easily. But the challenge comes with the fourth and beyond; those are likely to become too similar to the first three. In order to improve, you'll need to work to make deeper observations, and stronger memories, of your surroundings and your readings. I find that consulting various forms of "pop" divination, like blood-type horoscopes and zoological fortune telling (*dōbutsu uranai*) can be highly instructive.

During this step of the process, you need to first have a firm grasp on the character of your protagonist, or else any side characters will also be indistinct.

The basic way to differentiate your characters is to define your

protagonist, then make your other characters so that they don't overlap. When filling out their history sheets, simply use different answers; for example, if your protagonist is blood type A, then you should have your supporting role be someone type B or O.

When making supporting characters, it's also important that they provide chemistry and contrast with the protagonist. If your main character is cheerful and possesses a strong sense of justice, a supporting character might be dark and coolheaded, with a slanted view of the world. In my first published manga, *Poker Under Arms*, I drew the antagonist in ways that contrasted with the main character— black hair versus white, a light shirt versus a dark coat, without a hat versus with one, thick eyebrows versus narrow, and so on.

This remains true if your manga has a larger cast; just keep on making sure that your supporting characters have a different appeal than the protagonist. In terms of body type, you can have some be fat, some skinny, some muscular, some tall, some short, and so on. You have complete freedom. It can even be interesting to have a character that is almost identical to your main character except for a few minor differences.

When creating your characters, you don't have to approach your protagonist and supporting roles any differently. The major difference is that supporting roles don't have the same restrictions as the main character. While you can't let your protagonist become disliked by the readers, supporting roles can be backstabbers or the like. You can be free to make them unlikable, or even detestable. Surprisingly, those sorts of characters sometimes become the most popular. You only need to be careful not to let a supporting character outshine your protagonist.

MANGA IN THEORY AND PRACTICE

How to Use Supporting Characters

The principal way to handle to supporting characters is to have them overcome their flaws. In this way, you can connect with the readers. For example, a solitary character who has trouble making friends might gradually forge friendships. Another common pattern is an antagonist who gradually becomes friends with the main character.

Sometimes, supporting characters can grow in unexpected ways. My character Rohan Kishibe, who appears in *JoJo*'s fourth arc, *Diamond Is Unbreakable,* and other works, was not originally intended to be an important character, but when I started drawing him, I liked how he turned out and so began utilizing him more often through the story. In the design process, I had developed him enough to make sure he didn't overlap with Josuke or Koichi, who were the more major characters, in personality, quirks, or visual design, but Rohan's character expanded due to other elements in the story, such as the town of Morioh, where Josuke lives, and the friendships Rohan found there.

Names with Rhythm

When making your history sheets, you need to choose your characters' names with much care, for their names can determine the direction they'll take. Just as with naming a child, thinking up names for your characters can be a fun activity on its own. Just be aware that unconventional names can reveal a parent's style and values.

But after a hundred or two names, it's not all fun and games. If you just choose names that have kanji you like, after so many characters, you will without a doubt fall into a pattern. You need to bring craft into the process, like with Noriaki Kakyoin, where I used the

name of a location in Sendai, a city with a hometown feel.

Sometimes, you may want names that are intentionally similar. If my character Rohan (露伴) had a brother, I might flip through a kanji dictionary to find a related kanji (maybe something that shares the 雨 in 露) to signal that the two are brothers. Another method is to use similar-sounding names, like Oingo and Boingo in *JoJo*'s third story arc.

I don't usually set out to give my antagonists evil-sounding names, but many manga villains have names, like Matarō (魔太郎 / "devil boy"), that evoke images of death, darkness, and the underworld. You can also use royal-sounding names, like something-stein or something-berg, for characters whom you want to seem high-class. Try to be cognizant of the image your potential names imply.

How to Draw Characters: Jotaro Kujo

The most popular of my leading characters is Jotaro Kujo, the protagonist of *JoJo*'s third story arc, *Stardust Crusaders*.

When I started on this arc, my primary goal was to create characters with different personalities from those in arcs one and two, and so I narrowed the focus of the first chapter to Jotaro himself. On his character history sheet, I wrote that his father was a Japanese jazz musician and his mother was Joseph's daughter, Holly Joestar. Aside from a brief scene with the mysterious coffin from the conclusion of the first arc, which I included to foreshadow Dio's revival, the contents of Jotaro's character sheet—including his family history—formed the entire first chapter of *Stardust Crusaders*.

For this opening chapter, my only concern was how to develop the character and his history. It begins with when he was a child, and he was obedient and adorable, and said things like, "Nothing's

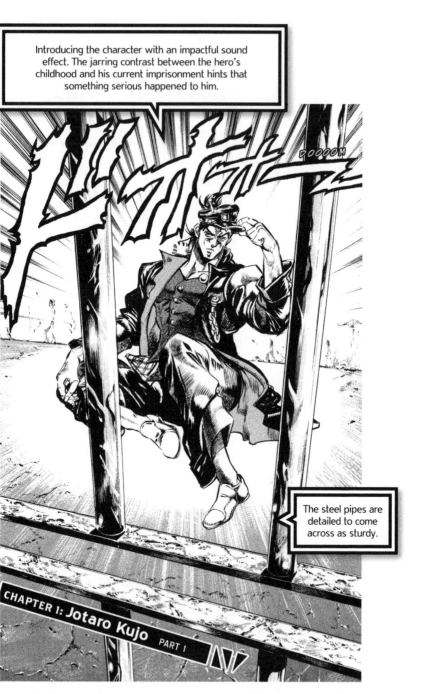

Introducing the character with an impactful sound effect. The jarring contrast between the hero's childhood and his current imprisonment hints that something serious happened to him.

The steel pipes are detailed to come across as sturdy.

CHAPTER 1: Jotaro Kujo PART 1

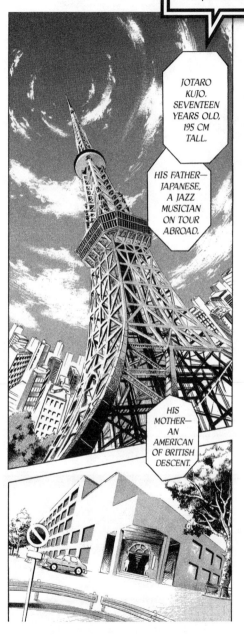

This part came from the character history.

JOTARO KUJO. SEVENTEEN YEARS OLD, 195 CM TALL.

HIS FATHER— JAPANESE, A JAZZ MUSICIAN ON TOUR ABROAD.

HIS MOTHER— AN AMERICAN OF BRITISH DESCENT.

PART
3

STARDUST CRUSADERS

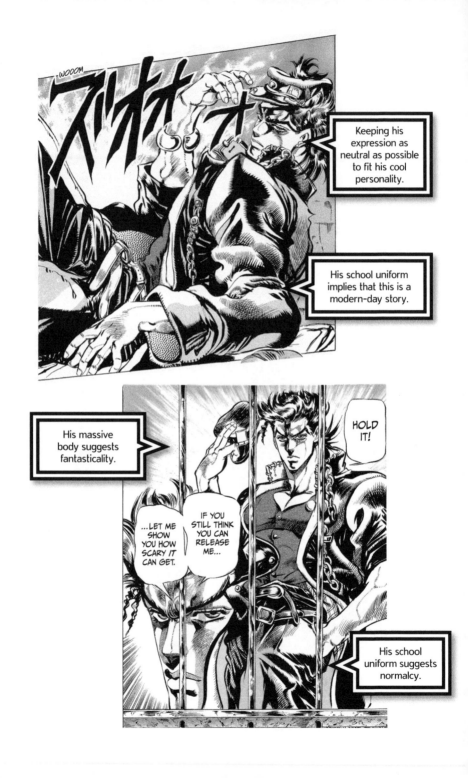

as good as your cooking, Mom." As he grew older, he started saying things like, "Shut up! Can't you get out of my face, woman?!" After that, we find him in a jail cell. These opening three pages left a lot of questions open for the readers, but as the creator I felt reassured that the arc was on the right track.

In order to restrain violent abilities that were beyond his control, Jotaro puts himself in jail and even tries to kill himself, but an unknown force stops him. This unusual opening is a perfect example of the *JoJo* world. Also, because the more secure his jail was, the more weight there would be behind Jotaro's actions, I put great care into drawing the cell with strong metal bars and other such details.

The first *JoJo* story arc is set in 1888, and the second in 1938. For the third, I continued on to 1988, exactly one hundred years after part one. I put Jotaro in a *gakuran*-style school uniform to make it immediately evident that the setting was contemporary and that Jotaro was a delinquent.

This is an example of how I communicate multiple pieces of information through the way I draw the characters and settings, and I did the same for the scenes of younger Jotaro and his family. Arcs one and two were set overseas, but by depicting Jotaro's house as a typical Japanese home, I could inform the readers that this story was set in Japan without having to stop to explain it.

The name Jotaro combined my *JoJo* naming style with the meaning of "successor" or "heir." To compare him with the protagonists of the series up to that point, Jonathan, from the first story arc, was a man of justice in a very traditional sense, and Joseph, from the second arc, was cheerful and flashy. In contrast, Jotaro kept his emotions hidden inside; no shouts of surprise or boisterous laughter. I made an effort to draw him as expressionless as I could. I took a page from my ideal image of a hero, Clint Eastwood, and gave him

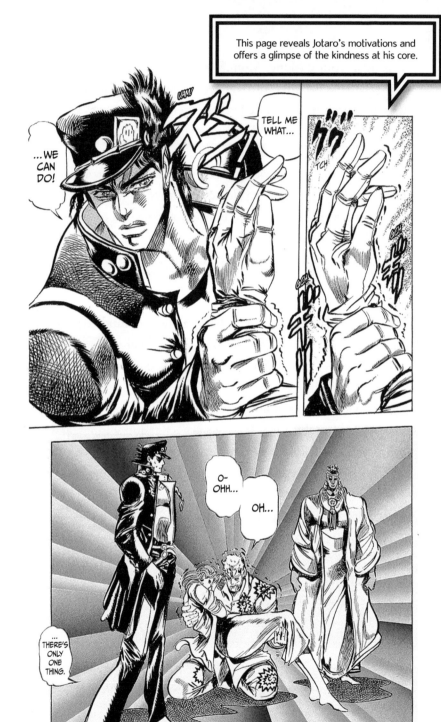

an economy of movement, and a presence that could be felt just by him standing. I carried this characterization through all of part three.

Jotaro was taller and his body had more of a sense of weight than my previous protagonists, but I had established that fact in the character sheets, and all I had to do was draw him as I'd already decided. I made him as tall as I did to evoke an air of the fantastic, while his school uniform represented the everyday.

When creating a new character, the first thing that must be decided upon is that character's motivations, but Jotaro's don't appear in the manga until chapter seven, when his mother, Holly, is endangered by Dio's reappearance. Jotaro usually pays little heed to his troublesome mother, but when she collapses, he is called to action. The outwardly gruff young man reveals the kindness that lies hidden beneath.

Strong Characters Are the Key to Serials

As I close off this chapter, I want to impress upon you that characters are essential to a serialized manga, and that a serialized manga is an absolute necessity for sustaining a career as a mangaka.

When I made my debut with *Poker Under Arms*, the reaction it received from the editors was simply, "We can't make this a serial." Though I'd finally broken into the industry, the editorial team wanted manga they could serialize. I realized that the suspense-driven shorts I had been making up until then weren't going to make the cut, and I found myself blocked by another wall.

Thrillers don't work for one reason: the most important component of a serialized manga is having an appealing protagonist, but thrillers as a genre place emphasis on the story, and their characters tend to be weak. I had intentionally decided to debut with a western because few other mangaka were making them, but I felt like the

choice had immediately labeled me as something of an oddity, and that I was already assumed to be incapable of creating a serial.

The works I loved, mysteries, thrillers, ninja stories, and so on— and not just limited to manga, but movies and novels as well—start with a violent conflict up front, and only later reveal the cause. But those aren't the more easily digested big hits. At the time, *Star Wars* (1977) was wildly popular, but I preferred *Carrie* (1976) and its tale of a girl with supernatural powers who exacts ferocious revenge upon her parents and bullies. I was well aware that what I liked and what became smash hits were two different things. But even knowing that, I couldn't shake my desire to remain true to the things that I personally enjoyed, and that I thought were good, and to not hew to what was currently in vogue.

Making a Living as a Mangaka

Soon after my debut publication, I realized that the manga I had been creating could not become serials, and I quickly learned that if I couldn't make serials, I couldn't make a living as a mangaka.

At the time, a mangaka could earn about 3,500 yen ($18, or about $45 in 2017 dollars) per page, which after taxes came out to about 3,000 yen ($15, or about $40 in 2017 dollars). *Poker Under Arms* was thirty-one pages, which only amounted to about 100,000 yen ($450, or about $1,200 in 2017 dollars). But even with a low page count, a manga takes considerable time. I spent about a month working on *Poker Under Arms*, but the prospect of earning a mere 100,000 yen a month was clearly untenable.

Working part time as I created manga was an option, but if I was to call myself a mangaka, I wanted to be able to sustain myself on my craft alone.

I tried to think analytically about what I needed to do. What I wanted to do—the kinds of worlds I enjoyed—didn't quite fit with the big hits. But if I wanted to make a living as a mangaka, I needed to be one who could turn his publishers a profit. Ideally, I would be able to create a hit manga within the realms that I liked, but my first goal needed to be to create something steady and sure that could keep me afloat. Once I managed that, I would find time between deadlines to work on minor passion projects.

At the time I was starting out, the most popular mangaka produced their big hits somewhere around their late teens, like the duo of Yudetamago, who debuted at age sixteen, or Yōichi Takahashi, who was making *Captain Tsubasa* when he was around nineteen. That meant that by breaking into the profession at age twenty, I was a fair bit behind in the game. When I compared myself to those accomplished creators, I couldn't let myself become idle. I was compelled by a sense of urgency: I had to get a serial in *Shonen Jump* as soon as possible.

Sherlock Holmes, Guardian Angel

Figuring out how to get from my previous suspense-driven short manga to a serial was a process of trial and error. But I knew that I couldn't just model my protagonist after someone who was already popular, because my editors would have no interest in the familiar. Overcoming that hurdle was to be my next objective.

I finally landed upon a character that felt right when I came up with *Cool Shock B.T.*, which became my first serialized manga.

On a basic level, the manga could be compared with Sherlock Holmes, with the protagonist, B.T., in Holmes's role, and his buddy, Kōichi, taking Watson's part. I emulated the structure of Dr. Watson

as the narrator and used Kōichi to propel the story. In *Poker Under Arms*, I also used a narrator to move the story along, and with *Cool Shock B.T.*, I thought that letting Kōichi serve as the narrator would deepen the sense of mystery surrounding B.T. and attract the readers' interest.

I made B.T. distinct from Holmes by making him a rascal of a boy. Much like Holmes, *B.T.* is a genius using his wits to overcome evildoers, but in my version the protagonist is a bad boy who uses his intellect to outdo his opponents and win through trickery. I aimed for a theme of evil defeating evil.

At the same time, I took the roles of the antagonists, who would typically be motivated by easily understood concepts like greed or wounded pride, and filled them with more unusual characters whose motives were harder to figure out. *B.T.* was published in the 1980s amid a growing wave of vicious, incomprehensible crimes, which resulted in those kinds of characters feeling contemporary and new.

Resistance to a Devil Boy

B.T. was first published as a one-shot, but I intended it to be a serial. Still, I struggled to obtain the go-ahead to move past the planning stage, and it took around two years before I managed it.

A major reason for this was pushback from the editorial team. No other manga in *Shonen Jump* featured a rule-breaking character like B.T., and that was a challenge I wanted to take on. But the response I got was that a "devil boy" had no place in a wholesome shonen manga magazine that held to the principles of "friendship, effort, and victory." Even the name, B.T., was a point of contention. By using two English initials, I was going for an air of mystique and for something fresh, but the editors merely found it incomprehensible.

But my manga's basis on a classic like Sherlock Holmes gave me a peculiar confidence, and I thought that if they were criticizing my manga without even understanding where I was coming from, they must surely be wrong. I felt as if Sir Conan Doyle was at my side, and I continued drawing the series and made a stockpile of stories despite not having secured serialized publication. Unless I obtained the go-ahead, they would never see the light of day. Luckily, the editor assigned to me understood my way of thinking and was my persistent advocate. In the end, the resistant editors got tired of saying no, and B.T. finally had his serial.

How I Learned the Right Way to Make a Successful Manga

Though I had finally started my first serialized manga, *Cool Shock B.T.* did not find popularity. Believing my characters and story to be good enough, I struggled with the question of why readers weren't accepting my manga. After the results of a survey given after *B.T.*'s third appearance, even my supportive editor lost confidence in the series' continuation.

But another survey, sent out after the final chapter of the then-canceled serial, showed that readers rated the ending highly. Even though the series lasted a mere ten issues, *B.T.* was sorely missed by many readers.

I met with my editor to get to the bottom of what was so different about that last chapter of a series that had otherwise been met with indifference. What we came up with was the introduction of a strong antagonist—in this instance, a creepy freckled boy. The boy appears without warning and carries out merciless schemes that drive Kōichi's family into terror and dismay. Up to that point, *B.T.*'s adversaries had all been big men who posed physical threats, but this

creepy boy possessed a ruthless intellect that gave chills to B.T., who had been well-established as a genius trickster himself. B.T. had his first worthy opponent. The heightened suspense drew readers into the conflict between him and the creepy freckled boy.

Another important difference was that in the final chapter, B.T. was fighting for the sake of his friend for the first time. B.T. still used underhanded tricks to best his opponent, but by choosing to give him the motivation of fighting for his friend, I brought him in line with the royal road of shonen manga. What I think happened was that their friendship naturally developed over the course of several stories. In a way, it felt like I had been forcing the stories at the beginning, but by the end, B.T. was fighting to protect his friend as if the alternative was unthinkable.

Cool Shock B.T. was over, but thanks to its popular final installment, I gained a deeper understanding of how to make a popular manga. Afterward, I left Sendai for Tokyo, and my career and journey as a mangaka began in earnest.

CHAPTER 4

HOW TO WRITE A STORY

When Stories Get in the Way

When I described the four major fundamentals of manga structure, I wrote, "It is possible for a manga to succeed based on characters or setting alone," but I can't think of a manga that stands on nothing but its story.

A manga written on nothing but plot developments would probably end up like a locked-room mystery, the core of which is the solving of tricks and riddles and battles of wits. The characters of note tend to be limited to the detective and the criminal, and they often feel the same as in countless other books. These types of works can have a shortcoming of "motionless" characters. Let me explain what I mean.

In shonen manga, characters often lead a story into different directions. Take *Kindaichi Shonen no Jikenbo* (The Kindaichi Case Files), which was strongly influenced by classic mystery novels. At first glance, the manga seems centered on its stories. But in reality, the main character, a high school student named Hajime Kindaichi, is the grandson of Kōsuke Kindaichi, a famous fictional private detective in Japan, and the stories place focus on his family legacy and his interactions with his friends, and on how he investigates. The pattern

is that of the story working on behalf of the characters.

The opposite of that, where the characters change to suit a story, must be avoided.

For example, let's say you have a protagonist—we'll call him A— who is established as being born in Shinjuku and who loves Shinjuku. If you make the story about something happening in Osaka, a city that has nothing to do with protagonist A, now you have to come up with some forced, laborious explanation for why A is in this city that he cares nothing about. If your character loves Shinjuku, the more natural setting for him to operate would be Shinjuku. In other words, the character determines the story. Not the other way around.

I'm not saying that no one can make a manga that centers on story and puzzles like a locked-room mystery novel. I even think it would be interesting to see. But just know that by choosing to go against manga's royal road, you'd be challenging yourself to an uphill battle.

Characters Are Vulnerable to Changing Times

So far, I've offered that a manga can come together without story, and that a manga focused on story alone is not one of the royal road. Despite that, I still believe that manga need stories.

This is because manga without stories have a weakness. When a manga revolves entirely around its characters, the more those characters take the world by storm, the more dated they become in time. This happens because characters reflect the time in which they were made.

The definitive character-driven manga *The Wonderful World of Sazae-san* was first written over half a century ago. If you were to read the original strips now, some parts would make little sense, and some of the meaning would be completely lost. If character-driven

manga aren't updated to suit the changing times, they will find it hard to survive.

If the question is how can you make a manga that will be read for generations, the answer is *story*. The anime version of *Sazae-san* has been able to continue across the decades because new episodes are being added that are constantly updating the show to be more modern. The episodes come together to form a continuous story that revitalizes the series. *Kochikame* began its first serial run in the 1970s, and one could say that the reason the manga can still support the main character, Ryo-san, is because new episodes are still being added that update Ryo-san as a character. If you compared the Ryo-san in today's manga with the one from the beginning of the series, I think the difference in tone and feeling would be evident. Take the current wave of unsophisticated *yuru-chara* (character) mascots designed to revitalize tourism and local economic development in cities across Japan. Most aren't given stories and are destined to become dated. The ones who are turning into strong characters, like Kumamon and Funassyi, are the ones who are being given plenty of good stories, and therefore story arcs, across various media and events.

When it comes to creating manga, the concept of episodes is incredibly important. As opposed to the overall story arc that continues throughout a serial's entire run, episodes are complete in each issue. These individual episodes play a far more crucial role than the direction of the overall story in capturing the readers' hearts and minds.

Let's say a story has the defeat of a nemesis as one large overarching goal. If the process of getting there is, say, just following one long road, or training really, really hard, the readers are probably going to stop reading before the story reaches its end. But if the journey is filled with episodes of various encounters and battles, the readers will be increasingly motivated to follow the story to its conclusion.

The episodes are where you create situations you think your readers will want to read, with your characters running into obstacles and going on adventures; these episodes then connect together into the story. Even characters that decidedly come from the 1960s can still feel fresh ten or even a hundred years later, as long as a powerful story takes hold of them and pulls the reader along. The classic manga that continue to be read across generations all share this unity of character and story. This is what I call manga's golden way.

The Immutable Rule of Story Writing

Now that I've hopefully convinced you that story is indispensable to manga, let's move on to what constitutes good stories and how to create them.

Any manga that can be considered famous, as well as any novel or movie, will share certain story beats that will never stop captivating audiences. The basic version of this structure can be summed up as *ki-shō-ten-ketsu*, or introduction (ki), development (shō), twist (ten), and resolution (ketsu). Let's use a fighting manga as an example.

- Introduction: Introduce the protagonist to the reader. The important part here is to have the protagonist appear as quickly as possible. The reader mustn't think, *When the hell is the main character going to show up?*

- Development: The protagonist encounters the antagonist or some hardship, etc.

- Twist: The protagonist rises to face the challenge, but an additional problem creates a dilemma. In this part of the story, the protagonist attempts to strike back at antagonist/hardship but the difficulties keep building,

and the readers keep turning pages to find out what will become of the protagonist.

- Resolution: A victory or other happy end.

For this example, I've greatly simplified the ki-shō-ten-ketsu story structure, but this is the foundation of any shonen fighting manga where the protagonist faces and defeats their opponents.

From this one base—introduction, development, twist, resolution—infinite variations can be born. There could be ki-shō-ten-ten-ten-ten-ten-ketsu, where a hero is beset by obstacle after obstacle, or ketsu-ki-shō-ten, where the ending is revealed first. You could lead with a scene showing the fallen hero, as if to give a preview of what is going to occur. That could be enough to make a reader think, "Hey, this is something different. I wonder what happened to lead to this moment," and want to turn to the next page.

Creators who willfully eschew the entire ki-shō-ten-ketsu pattern—for example, by making a manga that solely depicts their characters' uneventful daily lives—can still produce masterworks, but only when done with purpose and knowledge of the pattern in the first place. Without exception, you must have ki-shō-ten-ketsu in your mind when creating your stories. This is the immutable rule of story writing.

Internalize Ki–shō–ten–ketsu from Your Daily Life

The ki-shō-ten-ketsu structure is a way of thinking that you need to internalize through your daily life in order for it to become less something you have to think about and more like a kind of muscle memory. When you're making a manga, you're not going to stop at every part of the process to think, "This part is the introduction,"

"This part is where the development begins," and so on. If you want to become a professional mangaka, you will observe life around you for the ki-shō-ten-ketsu structure until it's ingrained within you.

I want you to become conscious of the presence of ki-shō-ten-ketsu in not just manga but in life, and in the everyday. Even a meal can provide a model example of the structure. Take a full-course dinner. At ki, the appetizer comes out. With shō, the meal builds into a pasta dish. With ten, the main course provides its gravitas, and ketsu closes the meal out with dessert. Each step comes together to tell a story. Love fits the pattern, too. Two people meet (ki), fall in love (shō), face trials in their relationship (ten), then live happily ever after or break up (ketsu).

Sports provide good examples of the story structure in everyday life. Each match develops along the ki-shō-ten-ketsu structure. The whistle blows the start (ki), the opposing team appears and the game builds with uncertainty (shō), the teams present each other obstacles in cycles of attacks and defense (ten), and a victor emerges (ketsu). If you look at it at that angle, sports manga naturally conform to the structure from their very conception.

I want you to awaken to the ki-shō-ten-ketsu ever present around you. Then, if you can internalize it, you won't have any trouble including the structure in your writing.

The Rule of Rising and Falling

Once you've learned the foundation of story structure, you next must be careful of the rule of rising and falling.

I want you to visualize a horizontal baseline against which you will measure the rise or fall of your protagonist's emotional state or circumstances. Earlier, I touched upon the importance of always

having your characters grow, but especially in shonen manga, your protagonists must always be rising, rising, and rising still, building and building, or you won't have a hit. To put it in the context of a sports manga, the protagonist might start at a district-level tournament, then state, then national, as he rises to meet the challenge of stronger and stronger opponents. This is a perfect example of an always-rising plot.

The common approach to battles in fighting manga is to always be raising the stakes, and creating a question of how far it will go. If the hero does this, the enemy does that; if the hero attacks like this, the enemy counters with that. This constant buildup may feel like an inflationary bubble that is bound to burst, but if you read any successful manga, you should find that on a basic level, the protagonist is always rising.

The ideal pattern is for the protagonist to overcome progressively tougher challenges as the pages turn, and for those challenges to make the reader believe the hero might lose, but the hero will always win in the end. A story's success will pivot on finding good ideas to keep this positive motion building.

The Protagonist Always Rises

Whether you're working in long form or short, when it comes to the story, the two ironclad rules are that you follow the ki-shō-ten-ketsu structure and that your protagonist is always rising. Even if you're changing up the structure to ki-shō-ten-ten-ten-ten-ketsu, through each *ten* your protagonist must always be growing.

I'll use *JoJo*'s part one, *Phantom Blood*, as an example. At the beginning, the protagonist—Jonathan—is a young man with a happy life in a noble family, but his enemy—Dio—kills his dog, lays his hands

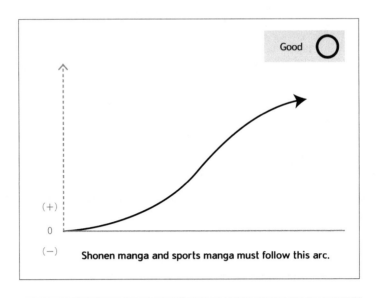

Good ◯

(+)

0

(−)

Shonen manga and sports manga must follow this arc.

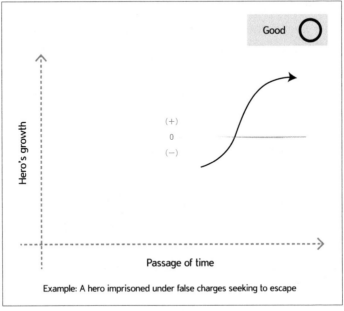

Good ◯

Hero's growth

(+)

0

(−)

Passage of time

Example: A hero imprisoned under false charges seeking to escape

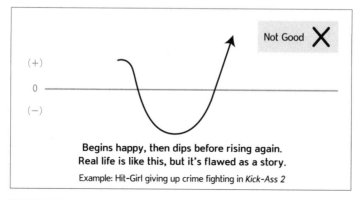

Begins happy, then dips before rising again.
Real life is like this, but it's flawed as a story.

Example: Hit-Girl giving up crime fighting in *Kick-Ass 2*

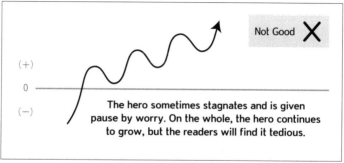

The hero sometimes stagnates and is given
pause by worry. On the whole, the hero continues
to grow, but the readers will find it tedious.

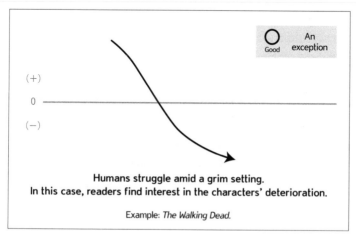

Humans struggle amid a grim setting.
In this case, readers find interest in the characters' deterioration.

Example: *The Walking Dead*.

on his girlfriend, and drives him into one hardship after another. If we're looking at that graph baseline, Jonathan is on the negative side here.

If you're reading that story in graphic novel form, that section is not a very large portion of the whole, but in a weekly manga magazine, each manga only gets nineteen pages an issue. That meant that Jonathan remained on that negative side for two or three weeks. That can be tough on a weekly manga, and sure enough, the readers didn't take to it, and I could feel their growing dislike of the constantly beat-upon protagonist. When an installment ends with a feeling of defeat, the readers' emotions will stay down on that negative side with the protagonist, and that will be reflected in the reader surveys. You'll get the best results by ending each week with some kind of victory, if possible.

But keep in mind that at the time, I intended for the story to begin with Dio invading Jonathan's world, and to start at that negative point from which Jonathan would rise. Though the readers spent about a month thinking, "This 'hero' just loses all the time!" during what was likely a tough read, I drew those chapters with the hope that they would stick with it for the ascent.

By the way, Dio also moves in a rising direction, like Jonathan. Dio accepts and embraces his evil nature and follows his dark path without hesitation. In other words, both Jonathan and Dio are living life with everything they've got, and both always maintain a rising personal arc. The violent clashes between those rising forces of good and evil form the basis of the *JoJo* series, and though the heroes and villains are always changing, that foundation has remained from part one all the way to today.

The Limits of a Tournament Structure

In order to create a scenario that constantly builds, mangaka of the 1980s turned to the tournament format. In a tournament, you have your first battle, and then the second, and the third, and so on, each against opponents who have also risen through their victories. The readers can anticipate that this rising action will continue all the way to the peak. Famous examples include *Ultimate Muscle* and *Dragon Ball*, and it's a reliable structure that nearly guarantees success.

But the tournament format isn't perfect. Just like in an economic bubble, the problem is what happens after you've reached the top. After achieving the top victory, the next tournament starts again from the bottom. A mangaka does not want to be in the position of having to face a redo of the same story. And if the creator tries to go through with it, the result will feel incredibly forced. Just from a creative standpoint, having started from the bottom and built the story up to the top, you can't tear everything down and start over and still be able to face the toil of building it back up again when you've already felt the exhilaration of the peak.

Assuming you're not planning on stopping the manga at the end of the tournament, your only option to keep going is to have a fall after the victory and another fight to reclaim the victor's title. But that would go against the rule of always rising and won't lead to a manga of the golden way.

Why Readers Appreciated *Stardust Crusaders*

During the height of the popularity of tournament manga, I was able to approach them as a reader and enjoy the excitement, but I couldn't help but wonder, from a creator's point of view, what the mangaka

would do after the top of the tournaments. At that time, *JoJo* was struggling in the reader surveys, and people even suggested that I add a tournament format to help me gain popularity.

But thematically, *JoJo* is in part about passing the torch across generations. If Jonathan climbs to the top of some kind of tournament, what will the next generation do? To have any kind of decline goes against the royal road to shonen manga.

I put some thought into how I could maintain that rising action without utilizing a tournament structure. What I came up with was a journey, like the long-running television series *Mito Kōmon*, or like a board game, where each step forward is met with an enemy to fight. I used this structure for part three, *Stardust Crusaders*.

At each step, an enemy is battled, but each enemy doesn't have to be stronger than the last; this avoids the tournament structure's inflationary increase in power from each fight to the next. Now, if the fighters aren't always increasing in might, then where is that positive forward motion? The protagonist and his allies are approaching a destination, and they're always moving forward. In *Stardust Crusaders*, the protagonist Jotaro and his allies fight many opponents as they head to their final adversary, now known as DIO. Because they never turn back, the story is never moving in a negative direction. I believe that *Stardust Crusaders* was able to elude the stagnation common to manga series because I was able to follow the rule of always rising in a way that didn't copy other mangaka.

Weak Enemies: An Unorthodox Method

Just as a tournament structure has its flaws, so does the journey structure have a weakness—though each location may change, the encounters can end up becoming too similar. The challenge comes in

making similar events still feel fresh.

In *Stardust Crusaders*, I changed up the battles by not having every opponent be strong, and instead used weaker adversaries on occasion. Because there's no thrill in an easy victory, I compensated for physical weakness by making them extra devious and frightening. The idea was to make these battles offer a different challenge than just might struggling against might. The first of these opponents came with Ebony Devil (the Stand of Devo the Cursed), whose strength and speed are sorely lacking, but whose attacks grow more powerful as Devo's hatred intensifies. By defeating a more varied roster of enemies, Jotaro and his allies grow mentally as well as physically.

Their final battle against DIO, their strongest adversary, awaits them at the end of their journey. To let the readers enjoy the suspense of each moment along the way, I only drew DIO's face in silhouette and refrained from fully revealing him until the final battle. I was worried that if I showed his face before then, readers would become too distracted by thoughts of the inevitable showdown and become less emotionally invested in the prior battles.

Don't Fall for the Temptation to Go Negative

To be honest, it is truly hard work to always build in a rising direction, and you will sometimes be tempted to have your protagonist lose or face a setback—if even just once—and to move the story in a falling direction. But you mustn't give in to that temptation and break the rules of the royal road.

Under the rule of rises and falls, you are allowed to start in a negative place and have the movement rise from there. But when it comes to that ever-rising direction, you can't make any compromises.

The reason this is so crucial is because you want your readers' state

of mind to always stay positive. If you look at it from their point of view, you'll understand that you never want to see the protagonist take a step backward.

Imagine a sports manga with a protagonist who is weak, friendless, and constantly bullied. As a starting point, we're on the negative side. But if the negatives continue, if he tries, and tries, and tries, and never succeeds, would you want to keep reading something so depressing? No, what people want is a positive story, where a loser triumphs over a bad situation to become a national champion.

Hitting Walls: A Failing Pattern

So then, what about the pattern where the protagonist is on a positive trajectory, then hits a wall and loses, and takes a step back just once? I think this is also no good.

I'm going to switch to an example from film, specifically *Kick-Ass 2* (2013), a sequel to the 2010 movie about a geeky boy who tries to become a real-life superhero. One character, whom I particularly liked, was a superhero called Hit-Girl. But in the sequel to the popular film, Hit-Girl gives up crime fighting and returns to normal life. A story like that will only irritate viewers, who will think, "Go back to being Hit-Girl! We don't want to see you not be Hit-Girl. Everyone knows you're going to go back to being her at the end." As expected, she does return to her vigilante persona at the end, but all that does is bring her back to square one. And that's hardly exciting to watch.

I think the creators of that movie probably wanted to show her going through normal adolescent troubles, but they should have found a way to include those elements with her still moving forward as a character. No matter how hard it may be to come up with such an idea, that work is necessary. If you end simply at the beginning,

the viewers will just think, "So what?" Perhaps a dip in the character's arc might have been all right if she had grown even further before the end, but the movie reaffirmed my belief that a sequel has to keep moving in a positive direction if there's to be a chance of it surpassing the original.

The trope of a superhero deciding to quit is my least favorite story, and it's not limited to that movie alone. For someone who is lucky enough to be a superhero to decide to quit is, in my opinion, a fatal negative turn. When a reader sees a character like that, they're only going to think, "What, you're not going to do anything? We all know you're going to return for the end, so just hurry up and do it already."

The Trap of Going Back to Zero

Another common story is the arrival of an impostor hero, but those always end with no overall change, and are another example of the failing pattern of returning to zero. Whenever an impostor shows up, the real hero is always going to win. This just isn't entertaining from the audience's perspective. It comes with the distasteful odor of a sequel coming not from a new idea, but from a desire to make a follow-up just because the previous title is selling well.

For one *JoJo* video game, the developers came up with a story idea where the protagonist is captured and then escapes. At first glance, this may seem like a positive-oriented arc, but it's really just going back to zero. He's captured (negative), escapes (positive), bringing him back to right where he was at the beginning (zero). In the end, I offered a different idea, and they fixed the story to give it a positive direction.

As an aside, if the hero is captured from the onset, that's a different matter. He's already captured (negative), but escapes and finds

freedom (positive), which makes it a rising story that starts at a negative point. That would be fine.

Story Taboos

While I'm talking about failing story patterns, this would be a good time to go over various things that mustn't be included in a story.

1. The Author Speaks

This is right at the top of the list of what techniques not to use. When the author inserts himself outside the panel, it's usually meant as a kind of fan service, and super fans might indeed be happy for it. But the story is what's most important, and interrupting it in this way creates a sudden rupture in the narrative. Also, any successful efforts to draw your readers into the world of your story will go to waste as you suddenly pull them out of it. To do this is to disrespect your readers who want to become immersed in your manga.

2. Coincidences

Say your protagonist is in a pinch, and then a meteorite suddenly falls, or a police officer happens to walk by, or an old ally shows up to save the day, or a god or gods appear, or a divine storm comes rushing in, or some other happenstance. It's not going to make for a particularly convincing resolution, is it? Now, if you've put in the work of foreshadowing it, that's one thing, but forcing something into the story that has

no relation to the plot, the characters, or the setting is always a bad idea.

3. The Protagonist Blunders

No matter how much trouble you're having coming up with an idea to put the protagonist into a conflict, you mustn't make the protagonist blunder into a problem of thier own creation. That in itself is a negative-oriented story. Let's say your protagonist is a policeman, and he goes out to investigate but forgets his badge and gun, and gets into a dangerous situation because of that unnatural premise. The very second a reader thinks "A cop isn't going to ever do that," you've probably lost that reader. Japanese movies often use such moments—shouting, "Are you all right?" while wildly shaking a dying person, a cell phone suddenly losing signal, going to shoot a gun only to find it's out of ammo—outside of a gag or parody, these all exemplify a pattern that is cheap and feels cheap, and are best avoided.

4. It Was All a Dream

This is my absolute least favorite literary device. "[The protagonist] was the criminal all along!" is in a similar vein. These resolutions only betray the reader, who has become deeply invested in the story, and has been living it alongside the protagonist. "Was it all a dream?" is a question with only one response: "Give me back the part of my life I wasted on reading this."

Don't Seek Reality in Entertainment

Obviously, reality doesn't always move in a positive direction. In life there are setbacks, and sometimes great effort still meets with failure. Trying to capture such realism may work from an artistic standpoint, but it's not the royal road to manga.

Say you had a romance where the main character has troubles with their true love, so they try dating someone else, or maybe they just idly fret about their situation. Such developments often occur in real life, but entertainment must always tell a rising story. The royal road to love stories is one of strictly rising action—no matter the obstacles, the protagonist will overcome them and unite with their love object.

Even biographies of great figures provide hope that their subjects will overcome troubles and foreshadow a happy ending. Readers want to read success stories, and that means that the protagonist will continue to rise while confronting any obstacles before them.

In a yakuza or gang story, the protagonist ascending to seize the top spot is a great story, but usually the narrative keeps on going to depict betrayal and downfall. Those, however, are downward narratives and, frankly, dangerous territory. *The Godfather* (1972) is a marvelous film as it shows Michael's rise to mafia boss, but it continues past the peak. In the sequels, Michael is beset by troubles and family betrayal in a series of realistic scenes that are brilliantly rendered, but from the point of view of the audience, they are simply unwanted and depressing.

Purposefully Attempting a Negative Arc

That said, I'm only discussing storytelling as it applies to the royal

road. If a creator wishes to purposefully tell a negative arc, I think that is wonderful. The important distinction is whether the creator is attempting the challenge with awareness or in ignorance.

With *The Godfather Part II* (1974), the contrasting depictions of Michael and the first don, Vito Corleone, show that Francis Ford Coppola had fully calculated what he was attempting.

Or consider the zombie movie genre—a personal favorite—which tells exclusively negative stories, where death is the only outcome. But those, too, are calculated. One could even say they go so negative that they become positive again. I don't want to digress beyond the topic of this book, so I'll leave it at saying that zombie movies, which present a relentlessly declining arc, are good until and unless they try to mix in positive elements, like friendship, hope, and love, and in doing so create a pattern of ups and downs—a losing combination.

Why I Killed Jonathan Joestar

If the protagonist's arc must remain positive, then it stands to reason that no matter what else happens, the protagonist must win at the end. A happy end is the very foundation of the Golden Way.

That said, depending on one's philosophy, that rule can be bent. The hero making a sacrifice to save someone else is one royal road to shonen manga, and if the protagonist has to lose for that noble goal, and it comes at the end of the story, that loss could mean the protagonist's death. Offering one's own life to save another may seem on the surface a terrible, negative-oriented development, but it can also be a positive, happy ending.

When Jonathan dies in order to save his beloved wife (and child) at the end of *JoJo*'s first story arc, that is a bending of the "always stay positive" rule. Killing off the protagonist is about as negative as a

negative can be and is unthinkable in a shonen manga.

But I sensed that in order for the Joestar family's noble lineage to be passed down, Jonathan needed to die. I know that readers might have been disappointed by his death, but Jonathan's blood and spirit passed on to the second protagonist, Joseph.

Many stories involve a shift from one protagonist to the next, while what's important carries on. We see this in works ranging from Steinbeck's famous novel *East of Eden*, a tale patterned on the story of Cain and Abel of two families in turn-of-the-century America, to Akio Chiba's manga *Captain*, where successive captains build a nothing baseball team into champions. When a story's themes include that of passing a torch, the death or replacement of a protagonist is acceptable; I might even suggest that's what makes those stories masterpieces. When I killed Jonathan in part one, some people said, "Can you do that? What happens to the series now?" But I thought back to *East of Eden* and *Captain* and took heart.

If you gamble by taking on that extreme negative, you must do so with the understanding of the rule of positives and negatives, and you must be looking ahead to how you will convert it into being a positive. In *JoJo*, Jonathan's grandson Joseph was the positive that enabled me to take that risk.

Hurl Your Protagonist into Peril

I'm often asked if I know a story from beginning to end before I start writing it, but that's not how I operate. I start with the destination the protagonist will arrive at, but before I figure out how, I first think about what characters will be in the story, and I hurl them into difficult situations. That's the point at which I start drawing.

As long as you know the characters and have ideas to put them

into trouble, you can make a story. Coming up with the concept can be hard, but in general (and this includes battle manga), the stronger the adversary, the more interesting the story becomes. Having a powerful enemy be the source of the protagonist's trouble is the best way to capture a reader's interest. The hero is completely prepared: well-equipped and trained. But the enemy is too strong, or maybe politically protected, or out of the protagonist's reach, and from there the challenges stem. That kind of situation can be incredibly thrilling and will make readers unable to put the manga down.

I'd like to go into a little more detail on potential avenues for devising these challenges. You could think of a location that is a kind of place you yourself can't go but presents a world into which you'd like to immerse the readers—for example, it could be space, or a snowy mountain, or a desert—and the difficulties will naturally emerge from the setting. It could be somewhere like a prison, where you wouldn't want to go for yourself, but you're curious to have a peek, and you can bring the readers along with you. Or you could think of the kind of situation you want to create—maybe it's a horror/suspense story, and you want to come up with a room where, once entered, even opening the next door becomes scary.

In creating *JoJo*, I started with the predicament. For example: My protagonist will go out to stop an evildoer who's plotting world domination by brainwashing people with superhuman powers or: I'm going to put a protagonist into a cross-country journey through the American West. After I come up with the challenge, I create the characters and toss them into the situation. That way, the characters can behave naturally in that setting.

Let the Protagonist Act

To explain what I mean by hurling a character into a predicament, let me turn to an example from a one-shot called "Poacher's Coast" from the *Thus Spoke Rohan Kishibe* series.

Rohan Kishibe is the protagonist and a mangaka based on myself, and in this story he goes to harvest abalone with his friend, an Italian chef named Tonio Trussardi, only to find himself locked in an unexpected battle.

Before I started this one-shot, my editor suggested I do a manga that involved some kind of food, so from the start I had planned on some kind of battle against some kind of food. Right at that time, I was watching a TV show called *Amachan*, and the episode involved bringing a paper-wrapped abalone to a shrine to give as an offering called a *noshi*. From that show, I learned that the shellfish are food for the gods, and I decided to go with a battle against abalone as the premise.

Now, what would happen if I were to put Rohan Kishibe into that predicament? Well, as long as I have a fleshed-out character with clear motives, and the ki-shō-ten-ketsu (introduction, development, twist, resolution) structure in place, I can put the character in that situation and naturally follow what their behavior would be, and how they would use their personality and special abilities to make it through. People often say that even if an author doesn't know where the story will go, the protagonist will act on their own, and I think this kind of approach is what that means. Just as people in real life will go about their lives with or without set plans for the next day, characters will act as they are meant to act. If you have the setting and the characters in order, you can leave the rest to them.

In "Poacher's Coast":

- Rohan is confronted by large abalones
- He assumes they won't be anything to worry about…
- They grab his leg and drag him underwater
- He runs out of breath
- Even more abalones latch on to him
- He sinks to the sea floor and sees the skeletons of dead poachers
- But he remembers something I established earlier— that octopodes are the natural enemy of abalones
- He uses this knowledge to break free

But rather than explicitly write a story, all I did was let Rohan the character act.

Also, in that story Rohan is fighting to save his friend, Tonio Trussardi; as I mentioned previously, fighting for someone else is of the royal road to writing a shonen manga hero. Rohan's original motivation is nothing more than satisfying his own curiosity, but then it shifts to that of protecting his friend. When Rohan becomes determined to save his friend's life, even at great risk to his own, he becomes an active character and "Poacher's Coast" a more appealing story.

The Hardest Part Comes Not at the Beginning, but Just before the End

However, if you allow a character's actions to dictate the entire story without having thought of how the end will be settled, continuing

all the way through without aim, the ending will likely be a letdown. Your manga's ending will determine whether the reader closes the book with satisfaction or in disappointment. You mustn't simply phone it in.

The point that's crucial here comes just before the conclusion in the ki-shō-ten-ketsu structure. Even more than the conclusion, this is the story's biggest moment. If you can face your protagonist with a dilemma that will excite your readers and make them think "How are they going to get through this?" you will have a story that will grip those readers and never let go.

In my case, I prepare that final challenge before it comes, but I don't go into it knowing how the protagonist will overcome it, not even after I've started. I face that crisis alongside my protagonist, and I try to think what I would do myself in that situation. As I let my characters act, the ideas begin to come to me.

In *JoJo*'s fourth arc, for example, as I was drawing that last battle between Josuke and Yoshikage Kira, I put Josuke in such a bad place that even I thought he might not be able to win. Like Josuke, I couldn't see a way out for him, and for a time, I was worried that I'd gotten myself into a bad spot. But I knew that I was doing exactly what I needed to do. I had to put myself into my character and be with him in that terrible struggle, and when he finally found a way through that impossible scenario, I was as elated as if I had actually gone through that experience myself.

Learn Storytelling from Hemingway

Your story will be created by your character's action, but it's important that they not try to explain the story.

Say I were to start a Rohan Kishibe one-shot with Rohan

expounding, "I am a mangaka, and I'm thinking about going out to find material for a new story. There's something that's really caught my interest, and it is…" Not only would that be clunky, it's not something I want to do. I believe that the story must be revealed organically through your characters' actions, natural conversations, mannerisms, locations, and so on.

A perfect example of this "show, don't tell" approach can be found in Ernest Hemingway's short story "The Killers." The story begins with a scene where two men enter a lunchroom and order their meals. The kind of men they are is revealed not through direct descriptions, but through the things the two men say. I'll pull an excerpt from the beginning to illustrate:

> "I'll have a roast pork tenderloin with apple sauce and mashed potatoes," the first man said.
>
> "It isn't ready yet."
>
> "What the hell do you put it on the card for?"
>
> "That's the dinner," George explained. "You can get that at six o'clock."
>
> George looked at the clock on the wall behind the counter.
>
> "It's five o'clock."
>
> "The clock says twenty minutes past five," the second man said.
>
> "It's twenty minutes fast."
>
> "Oh, to hell with the clock," the first man said. "What have you got to eat?"
>
> "I can give you any kind of sandwiches," George said. "You can have ham and eggs,

bacon and eggs, liver and bacon, or a steak."
"Give me chicken croquettes with green peas and cream sauce and mashed potatoes."
"That's the dinner."
"Everything we want's the dinner, eh? That's the way you work it."

Without writing, "The two men have killed before," or "They have guns," or "They are hired killers," or anything of that sort, the back-and-forth dialogue creates a vivid image that these two are not average men, and are some sort of criminals.

The short story continues, almost entirely using dialogue to paint the scenes, and that's all it needs to flesh out the characters and setting. The story is a good example for showing you exactly how to write, and its strong influence can be felt in the tough back-and-forth dialogue of hardboiled detective fiction, in Quentin Tarantino's movies, and beyond.

Dialogue Is Best When Natural

When writing dialogue, the basic aim is to keep it feeling natural. As your characters go about their actions, don't overthink the dialogue; just write what they would naturally say in each situation. Later, you can go back over the lines and make sure they are understandable.

Say a pretty girl suddenly appears before our protagonist. Does he get nervous? Does he flirt? Does he tease her? Does he approach her respectfully and with good manners? From slight differences in his mannerisms and between the lines of his speech, the character's nature will be revealed.

Also, dialogue in a manga is never made more cool by using

obscure or foreign words. In my opinion, it's best not to overthink the dialogue or add in dressed-up words in an attempt to elevate the script.

Ultimately, the best approach to communicating your story is to write characters with a way of thinking that's relevant to your own life, and to write dialogue that is easily understood and similar to daily speech. This will allow your story to reveal itself and help you express the world of your creation.

If I suddenly walked into a desk, I'd probably say something like, "Fucking hell!" or "What the hell is a desk doing here?" Those are the kinds of lines that would come natural to me if I were in that situation. I wouldn't say, "I hope I didn't hurt that desk," or "Wow, that was something else." I'm often told that the dialogue in my manga is distinctive, but I'm only writing lines based on the way I actually think and talk in my daily life.

Characters vastly different from yourself are an exception to this rule and will likely require research. Your characters are an important part of establishing the setting; their professions may have jargon, as with sushi chefs, or there may be certain words someone like your character would never say. In the case of historical fiction, you may or may not want to reproduce the language of the time, but if you throw in a few words from that period, you can better convey the sense of being in that time.

Insert Flavor in Ways Only Manga Can

One more thing on dialogue—because manga has the ability to draw readers into a fantasy world with the turn of a page, dialogue calls for more than being natural, but also to have feeling that only manga can include.

Let's say there was, as is common in Japan, a truck with a loud-speaker advertising an electronics recycling service as it drove down the street, and its message was more unctuous than polite. You might write something like, "May I have your attention please. If you have any unneeded appliances or computers, don't hesitate to consult with us!" But in this case, words alone won't convey the intended nuance.

If you're in a situation where that kind of nuance is required to express your characters, you can use other elements of manga to convey emotion or tone of voice.

It's also important to use beautiful and correct language, but when it comes to expressing a manga's world and characters, a mangaka shouldn't rule out straying from what's in the dictionary. By using more vernacular speech, you can make your characters more distinctive.

How to Make a Suspenseful Story: *JoJo's* Third Story Arc

I'll close this section with an explanation of how I created the story for chapter seven of *JoJo's* third story arc, *Stardust Crusaders*. This chapter plays the important role of developing the motive of the protagonist, Jotaro, for setting out to fight DIO.

The chapter begins with Jotaro and his grandfather, Joseph, unable to find his mother, Holly, at home. In the still and quiet house, Avdol—Joseph's friend from Egypt—finds a spoon on the hallway floor. I could have then cut directly to Avdol finding Holly collapsed in the kitchen, but that would be too direct and, lacking any feeling of surprise or drama, the scene would fall flat.

Instead, I began with a panel of the spoon lying in the hallway, then as Avdol moves into the kitchen, I presented suspenseful angles

of bowls and pans strewn about the kitchen floor. This gives readers a sense of unease as they question why everything is on the floor. Only then did I continue on to reveal Holly unconscious. The intent was to heighten suspense and build to the realization that Holly had suddenly collapsed while doing housework.

I like to use this method of suspense. Pursuing a mystery is the very definition of suspense, and the pursuit of the unknown brings out instinctual feelings of unease, curiosity, and fear. That's why people are drawn in by suspenseful techniques. I feel that suspense can be applied to any genre, including sci-fi, horror, drama, and more, and serves as the foundation of entertainment that appeals to human nature.

My goal with this chapter was to show Jotaro's motivation, but at the end I also added a two-page spread featuring the characters represented as tarot cards. When I designed the four main characters—Jotaro, Joseph Joestar, Muhammed Avdol, and Noriaki Kakyoin—I made sure that they would be recognizably distinct from their silhouettes alone. I also gave Avdol a more ethnic feel, not only to provide a contrast with Jotaro, but to foreshadow the journey leading to his home country of Egypt.

This image conveys the idea that a group of people are joining a shared fight, much like in the movie *The Seven Samurai* (1954), and in doing so informs the reader that this manga will be headed in that direction. The design also incorporates the idea that the four are connected by something akin to destiny and signals those connections as a primary theme for *JoJo*'s third story arc.

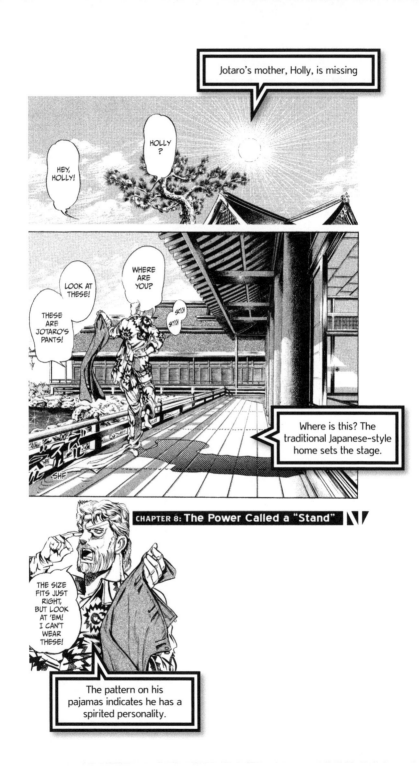

Jotaro's mother, Holly, is missing

HOLLY?

HEY, HOLLY!

WHERE ARE YOU?

LOOK AT THESE!

THESE ARE JOTARO'S PANTS!

Where is this? The traditional Japanese-style home sets the stage.

CHAPTER 8: The Power Called a "Stand"

THE SIZE FITS JUST RIGHT, BUT LOOK AT 'EM! I CAN'T WEAR THESE!

The pattern on his pajamas indicates he has a spirited personality.

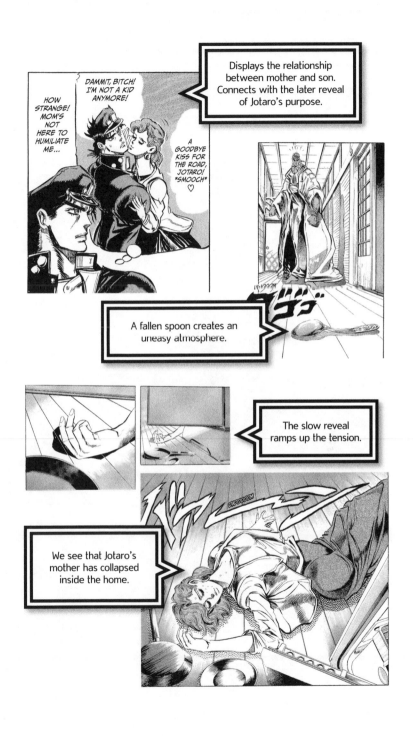

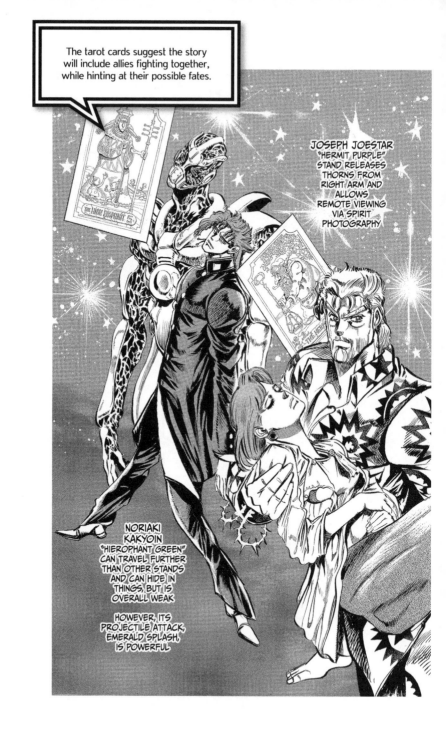

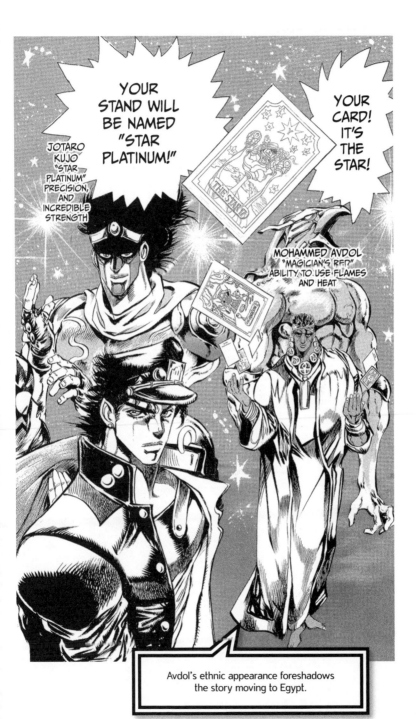

Avdol's ethnic appearance foreshadows
the story moving to Egypt.

CHAPTER 5

ART EXPRESSES EVERYTHING

Art Is the Mangaka's Killer Technique

Artwork encapsulates and unifies the four major fundamentals of manga structure—characters, setting, story, and theme—and is of extreme importance in manga as a medium. Theme and setting are defined by the art, and the expression of characters and story relies on it. When it comes to manga, art is god.

Manga aren't made with words alone and cannot lean on music or sound effects. This may be stating the obvious, but art is what makes a manga a manga.

Your foremost consideration as a mangaka is what kind of art you will draw. Art is the mangaka's killer technique.

The interesting part is that the art doesn't necessarily have to be good. Just because a manga is drawn well doesn't mean that manga will be a hit, and conversely some manga might make you think, "How is something drawn this poorly so popular?"

This phenomenon began to arise not long before I entered the field. Previously, anyone who was a mangaka, like Osamu Tezuka or Tetsuya Chiba, was a skillful artist by any measure. When I started to see hit manga with art that seemed unprofessional, it came as a shock. This posed an inescapable question: why were they so popular

despite not being well drawn? Or, to go further, what made them different from less popular manga?

The Must-Haves of Popular Manga Art

When people call certain art "good," I think they generally mean that the representations are authentic. Well-regarded drawings include those that:

- Have a cohesive design
- Accurately depict light
- Provide a sense of shape and space

Or, more specifically, they depict:
- Pretty depictions of flowers
- Appealing depictions of women
- And many others…

In other words, they are realistic drawings that provide a sense of the real thing. But in the world of manga, realistic artwork made with superior technique is often met with total indifference by the audience.

So then, what's the difference between the poor artwork in manga that sells and the good artwork in manga that does not? The secret to artwork that sells is that the artist is instantly recognizable from their drawing.

To put it in more concrete terms, popular manga are the ones where you can look at them from fifteen, maybe thirty feet away and

think, "Oh, that's so-and-so's manga." Around ten years ago, when everyone was still reading manga on the trains, the popular manga were the ones which had that unique element in the artwork that let you tell at a single glance who drew it, even if you were standing two or three doors away from the reader. On the other hand, manga with an art style that blended in with the others tended to perform poorly in the reader surveys.

As soon as I made that observation, I became convinced of the importance of using an artistic style that could identify the mangaka at a single glance. Just as with handwriting, everyone's art style will naturally reflect their individuality. But beyond that, a manga's art work needs distinctive designs and mood.

Realism and Signification

Approaches to drawing can be broadly divided into two groups:

1. Realism
2. Signification

Realism in art seeks an imitation of reality, like a plaster bust. A drawing in this manner, when done with skill, will be recognizably good to anyone's eyes.

Signification is drawing an object in a way that is recognizable at a glance. Three circles grouped together can be recognized as Mickey Mouse, and a circle with some blue in it as Doraemon. That's the creation of a signifier. The artwork of popular manga can be summarized as effective signification.

With manga, a medium that is always working toward many goals, you need to draw pictures where both approaches coexist.

No matter how important signification is for sales, the pursuit of realism is needed to breathe life into your work. Much like Rohan Kishibe sliced open a spider with a knife to watch how it suffered, some aspects of manga call for realism. It would be hard to imagine a culinary manga without realistic—that is to say, appetizing—depictions of food.

Realism and signification oppose each other like oil and water, but it is possible to utilize both at the same time. This is perhaps best typified by Akira Toriyama's artwork. His style is instantly recognizable, yet his robots and gadgets are drawn in intricate detail down to the smallest parts, and with skillful technique. His characters' punches and other fighting moves have a visceral sense of speed, but other elements of his drawings are symbolized to the point of being simplistic, often leaving plenty of white space.

If you want to understand how incredible Toriyama is, you need look no further than his portrait art. Portraits are typically either rendered realistically or as caricature. Realistic drawings lose the artist's distinctive qualities, but when the artist's style is retained, the portrait often no longer resembles the subject. Toriyama's portraits, on the other hand, resemble their subjects while still remaining patently his—they are a fusion of oil and water. His mastery of his craft is by all rights incredible. Not every mangaka, or artist, is capable of such a feat.

Simultaneously utilizing realism and signification is an important aspect of manga art, and every manga popular today belongs to this continuing movement best represented by Toriyama.

CHAPTER 5

How to Pursue Both at the Same Time

So then, how do you simultaneously pursue realism and signification when they are opposing qualities? To put it simply, the important parts need to be realistic, and everything else doesn't.

In a sports manga, the sports scenes might be drawn in depth, but the protagonist eating a meal doesn't require the same level of realism. A titillating manga might emphasize a woman's eyelashes, lips, and bust, but can fully portray the intended eroticism without realistically depicting her nostrils.

Furthermore, if you pursue realism in all things, the readers won't know where they should be looking. I've made the mistake of becoming too passionate about drawing a scene and getting carried away, and ended up putting too much onto the page. When working on the climax, or on another scene when it's time to give it your all, you need to be careful not to over-draw and make the page excessively dense. In my current serial, *JoJolion*, I'm giving the manga a tempo; keeping the drawings light when I want to ease up, and putting heavy detail into the action scenes.

Just as making everything realistic can be a problem, some genres are hard to pull off with only signification. If your goal is to create a scary atmosphere, like in a horror or suspense story, some images, when drawn too simplified and symbolized, might not be as vivid or frightening as desired—for example, if you wanted to convey the pain of a finger being severed.

Sci-fi and fantasy are two other genres where realism is required to establish the setting. Even if you are depicting an imaginary world, it's the touches of realism, like detailed machinery on a robot, that draw readers into that world. I'll go into this topic in more detail in the chapter on settings.

123

If You Keep Drawing the Same Things, You'll Become Outdated

Given that a manga with crudely drawn art but effective signification can still become a hit, if you were to ask me which takes priority, signification or realism, my answer would be signification. But there is also a danger; sometimes manga symbolized without much thought can succeed by chance, and if the creator becomes complacent and doesn't grow, the audience will come to find it outdated and will move on.

In the 1970s, when I first started creating manga as a hobby, the standard was that men were to be drawn with thick eyebrows, and women with thin ones. But at a certain point, men also came to be drawn with thin eyebrows, and thick eyebrows were seen as uncool. If I were to draw my male characters with thick eyebrows now, they would seem outdated.

Younger mangaka can draw male characters with thin eyebrows as a matter of course, but since I grew up drawing thick eyebrows, I internalized that drawing style and had to spend much conscious effort in correcting myself. To me, male characters with thin eyebrows carried the image of a secondary part in a girl's manga, perhaps a rival in love or a callous, mean-spirited character, and ridding myself of my internal resistance to drawing thin eyebrows on men took considerable effort. I finally got over it when drawing Josuke, the protagonist of *JoJo*'s fourth story arc, *Diamond Is Unbreakable*, but until I did, I couldn't help but feel the looming danger of my art becoming outdated.

For so long, I had felt that thick eyebrows were a rule, but they weren't a rule—they weren't anything but a mere assumption. Had I clung to drawing thick eyebrows, my artwork would

have appeared dated.

If you want to keep developing your art along with the times, you need to make active efforts at destroying such assumptions. But in order to do that, you must first master the fundamentals of drawing.

Learn the Meaning of Objects

While art may have trends, I don't think there are any rules like, *You must draw exactly like this* or *Certain kinds of drawings are always going to be a hit with readers*. Although, as I wrote above, it is important to respond to the demands of the era, ultimately the artist should draw what the artist wants to draw. With that said, because humans—or possibly, anthropomorphized animals or machines—will become important characters in your manga, you'll be well served by mastering the fundamentals of drawing still-lifes and portraits. Without studying the basics, your technique and your ability to express your ideas will never develop. Even brilliantly gifted child artists aren't guaranteed to be able to draw such remarkable paintings as adults. If you want to, as an adult, be able to draw pictures as you imagine them, you can't avoid studying basic techniques.

Distorted proportions are of course acceptable in artwork, but only when created on the footing of fundamental technique. First you master the basics, then you can tear them down. The foremost examples of signification, like *Doraemon* or *Dragon Ball* or Mickey Mouse, all stand on this solid footing.

Master the Golden Ratio

The basis of portrait drawings lies in the universally appealing golden ratio. If you master just that one concept, you'll be able to design any

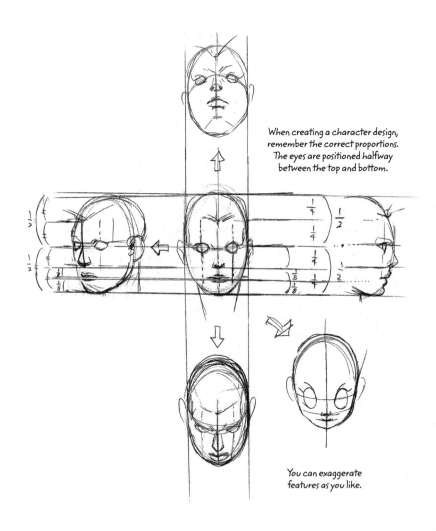

When creating a character design, remember the correct proportions. The eyes are positioned halfway between the top and bottom.

You can exaggerate features as you like.

kind of human character. Let's use faces as an example. People see themselves every day; we like our own faces, and our drawings naturally tend to resemble our own selves. There's nothing wrong with that, exactly, but if you want to create drawings to which great numbers of readers will be receptive, you must go beyond that internalized sense of beauty and learn the standard of beauty—the golden ratio.

A character that is drawn without the golden ratio as a foundation will seem inherently strange. An untrained artist may by chance succeed at designing one character, but any subsequent characters would be indistinguishable. Or, in another common pitfall, an artist could be good at drawing a face from the left side, but not the right. Any attempt to mask that by only drawing characters facing a certain direction will be quickly sniffed out by readers who will then begin to wonder if the characters are drawn, or simply stamped over and over again. Readers are unsparingly exceptional at seeing through to an artist's true level of ability.

I'll let my sketch to the left briefly explain the basic rules of drawing faces.

Where on the face do the eyes, nose, mouth, and hairline go? It's the same with every face. Even if you change the proportions of the individual components, each always appears at the same relative location. Learn them. Once you accomplish that, you'll be able to draw heads from above, below, and from the side to create three-dimensionality, and you'll also be able to enlarge the eyes, or perform other deformations to create supporting characters with a different-than-ordinary feel.

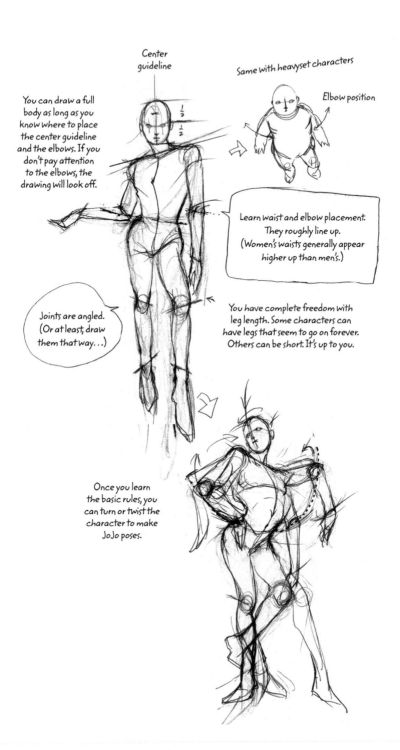

Center guideline

Same with heavyset characters

Elbow position

You can draw a full body as long as you know where to place the center guideline and the elbows. If you don't pay attention to the elbows, the drawing will look off.

$\frac{1}{2}$
$\frac{1}{2}$

Learn waist and elbow placement. They roughly line up. (Women's waists generally appear higher up than men's.)

Joints are angled. (Or at least, draw them that way...)

You have complete freedom with leg length. Some characters can have legs that seem to go on forever. Others can be short. It's up to you.

Once you learn the basic rules, you can turn or twist the character to make JoJo poses.

Learn to Draw a Robot with Moving Joints

Once you've learned the golden ratio as it applies to faces, the next step is the human body. Work on sketching the body in the following order:

1. Anatomical and skeletal drawings
2. Nudes (how the muscles connect to bones)
3. Clothed figures

Pay close attention to two important points:

- The center guideline (the line that goes down the middle of the body)
- The placement of the elbows and waist

If you can learn those two elements, you'll be able to draw a natural figure, which can be rotated and twisted, and that's how you get a JoJo pose. Also note that the joints are angled, and when viewed from above, make a helical shape. In the case of a clothed person, gravity will create folds in the cloth near the joints according to established rules, and you shouldn't be haphazard about drawing them.

Once you have a grasp of these concepts, you'll be able to draw characters with life and a wide range of movement. Basic methods of studying include observing established mangaka's drawings, but I would also recommend looking into reference books on anatomy for artists.

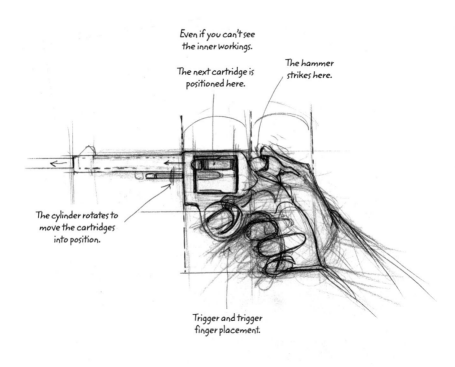

Even if you can't see
the inner workings.

The next cartridge is
positioned here.

The hammer
strikes here.

The cylinder rotates to
move the cartridges
into position.

Trigger and trigger
finger placement.

Aim for More than Mimicry

As mangaka build their careers, there is a tendency for their aesthetic taste to stagnate and for their drawings to become dated. To avoid this, it can be helpful to occasionally retrain an objective viewpoint on beauty in order to adjust your aesthetic sense.

My only word of warning—and this is something I ran into— is that if you start out by copying the works of the mangaka who inspire you, but you want to become a professional yourself, you mustn't stop there.

If you are mimicking a style, don't simply do so thinking, "Say, this artist does good drawings." Instead, try to deepen your understanding by taking a more analytic approach. For example, "The skeletal structure is correct." Or, "Which parts of the character's design are effective signification, and why?" Or, "What was the mangaka trying to achieve by drawing in this way?" Through repeating this process, you should start to see in your own drawings what you personally enjoy in them and what you want from them. If you can make those kinds of breakthroughs, you will be able to find your own worlds to create, and you will develop an art style that belongs to you and that isn't a mere imitation.

How to Draw Guns

Though this connects to the later topic of setting, I want to emphasize the point here: to understand the fundamentals, you must understand not just the structure and workings of the human body but those of machinery and tools as well. For example, if you are drawing a motorcycle or bicycle, and you don't understand how the wheels are attached or where the handlebars are placed, the result will

be unsuitable for riding upon, and your setting will become incoherent. If you base a robot's design on realistic mechanical movement, you can take into account its joints and other moving parts to create a far more lifelike robot than those of the past with their overly simplistic, rounded joints.

Occasionally, I'm asked to judge submissions from up-and-coming mangaka, and when I read a manga that contains something like a gunman who has a gun that seems nonsensical, that's enough to make me not want to keep reading. When it comes to firearms, even if you're not drawing the internal workings, you need to understand how they work in order to put the trigger and the shooter's grip in the right place. If you don't understand that the magazine feeds into the chamber, which lines up with the muzzle, you'll wind up with bogus-looking proportions, so that when the trigger is pulled, no bullet would realistically come out.

I keep a model gun in my office, but simply looking at the outer appearance isn't enough to gain understanding of the inner workings; if you can arrange for it, I suggest dismantling one for real to see how it comes together. I've illustrated this with a sketch, so that you can see how the hammer strikes the back of the cartridges to fire the bullets, and where the trigger and trigger finger are placed.

This idea goes beyond firearms; whatever subject you draw will have its enthusiasts. If you draw it wrong, you'll be found out, and you'll hear about it. More than that, even readers who aren't fanatics will still realize that something is off with your drawing.

How to Draw Fire, Water, Air, Light, and Stone

Fire, water, air, and light all have movement, and how to draw them is difficult to explain in words. But drawing them correctly will help

connect your manga to reality, and they will show up in every manga. I would hope that anyone who wants to become a mangaka would study these subjects; photography can be a good resource.

- Fire = drawing wind

If something explodes and you want to show the flames of the explosion, you can do so by drawing the movement of the surrounding wind. Burning objects are drawn in silhouette.

- Water = drawing gravity

When an object falls into water, how does the water splash? When a cup breaks, how does the liquid inside spill out?

- Air = drawing lines of motion toward the viewpoint

By showing distance, you can convey air.

- Light = drawing shadows

Stone isn't dynamic like the other elements, but drawing stone, rock, and earth is also important:

- Stone = drawing shadows

Don't just show the edges, show the recesses.

When illustrating rocks, creating a sense of weight is important (see the image on page p. 192). Also, keep in mind that rocks in an African desert will look different from rocks in the American West; do the research necessary to be able to represent the differences in your drawings. A rock and mineral guide can be useful there.

I constantly struggle with trying to describe to my assistants how fire, water, air, light, and rocks are drawn. Ultimately, I don't think

Water = drawing gravity. Show where water has pooled and where it's flowing.

Left: Fire = drawing wind
Below: Air = drawing lines of motion toward the viewpoint

Light = drawing shadows

there's any alternative path to improvement aside from trying, failing, and studying. But you should do whatever practice is necessary for you, because those subjects are of great importance to drawing a manga.

The Paper Is More Important Than the Pen

Once you begin drawing in earnest, you may become concerned with what types of drawing instruments to use, whether felt-tip pen, brush and ink, computer software, or what have you. My answer is: whatever you find easy to work with that will deliver the type of drawings you envision. I used to hear advice like "You have to use a G-model nib pen" or "Mapping pens are good," but because the same tools produce different images in the hands of different artists, it simply comes down to preference.

As for myself, in the past I primarily used G-pens, but now I only use them when I want firm lines, like for the outlines of eyes and faces, and the other 90 percent of the time I use either water-resistant felt-tip pens or brushes. Because G-pens contain metal, they are considerably heavier than marker pens or brushes. If you draw with a heavy pen for ten hours a day for a week, you'll probably get a repetitive stress injury. Brushes are the least taxing drawing instrument, but it takes time to get accustomed to the feeling of their soft, floppy tips.

Felt-tip pens come in many varieties, and you'll want to rigorously examine them for resistance to water and erasers, but in my opinion, the choice of paper is what requires the greatest care. Cheaper paper won't hold up through prolonged work; this is not the place to be cutting corners.

That's not to say that there's a certain price level dividing suitable paper from the rest. Rather, you need to choose paper of a quality that

matches your goals. Obviously you want paper that doesn't wear out your eyes when you look at it, but other qualities—ink absorption, tint, roughness, and so on—are best left to your personal preference.

Being Told You're Not a Good Artist

Sometime after you begin drawing regularly, there will come a point when you think, "This just isn't working out lately." When this happens, you may become somewhat worried, but if you keep drawing, you'll be able to break through it. The very fact that you're worried about it means that you're trying.

For a time after my professional debut, when I wasn't yet blessed with a hit, my editors gave me various bits of advice. I didn't take their words at face value, but rather looked for the underlying problem: my drawings weren't good enough. Though my peers, like Yudetamago, made their debuts with styles recognizable at a glance, I was still struggling with how I should draw.

My artistic ability when I drew *Poker Under Arms* was that of a kid. Even the critiques from the Tezuka Award judges went along the lines of, "entertaining, but poorly drawn." They were right; I was self-taught, with far too much beyond the limits of my knowledge. When I wanted to draw a black space with white lines showing through, I would alternate drawing the black and the white, black and white, one at a time across the whole space, and my editor would say, "Come on, look here, your lines are sticking out from the edges. Even a child could do better. Fix it." Such was the level of my knowledge that I had yet to learn that the basic technique was to fill in the solid area with black, then draw the white with poster paint.

I Found My Style in Italy

I wanted to learn more about drawing by becoming a mangaka's assistant, but I lived in Sendai—far too distant from Tokyo to make a commute possible—and I had to give up on that idea. After my debut, self-study remained my only option, and as I kept on drawing my manga for publication, I unflaggingly continued studying the fundamentals through sketching and any other means I could think of. It took years before my efforts bore fruit. I studied and imitated the drawings of my favorite mangaka, like Sanpei Shirato and Mitsuteru Yokoyama, and made many attempts through trial and error to find my answer, but nothing seemed to work. Even still, amid the tempestuous doubt, I kept on studying the basics of drawing, and I continued to practice.

You might be wondering why I felt all that was necessary. I wanted to draw real suspense, with scenes where a needle going into a finger would feel painful, and to do that I needed to pursue realism—how to draw the fingernails, how the muscles connected, how to give the fingers three-dimensionality, and so on—while also including signification.

My breakthrough came just before *JoJo* was first serialized, when I went on a trip to Italy.

If you were to sum up what makes my art distinctive in a single word, it would probably be the posing of figures, and that is something I acquired on that trip. And since you can't draw a character posing from their face alone, I always draw sketches for fans as bust illustrations with the shoulders indicating a characteristic pose.

Though I did have a desire to visit an authentic Western art museum, that wasn't why I went on my trip. I happened to go to the Galleria Borghese in Rome, where I saw Bernini's famous sculpture

Apollo and Daphne, and thought, "I wish I could draw this in a manga!"

I had seen pictures of the work, but sculptures have to be seen in real life to be truly understood. When I was able to see it, to really take it in, from the back, from below, and from many different angles, the statue's beauty and intensity overwhelmed me.

If you're unfamiliar, *Apollo and Daphne* depicts the myth of the nymph Daphne transforming into a tree to escape from Apollo's embrace. I felt like I could look at it forever, appreciating the artwork's wonders; how Daphne seemed to twist and rise up as she underwent her transformation, how exquisite the marble leaves were, how the sculptors had been able to fashion such a wonder from a single block of stone.

Such twisting poses were rarely found in Japanese museums, and I had seen few such artistic expressions in the works of the preceding mangaka. There's something sensual about such poses, too, in a good way. Since I had already built a foundation of technical craft, I needed only to add in what I had experienced in Italy and in doing so create images that reflected my perspective. Since I finally gained an artistic style I could claim as my own, I've had vastly fewer occasions to feel distressed by editorial criticism.

What Becomes Memorable About a Character's Pose

Poses are appealing because they remain in people's memories. Just look at Michael Jackson; his poses are eternally unforgettable. Because characters' poses can reveal much about them, down to what emotions they are feeling, poses are an incredibly important element of drawing.

I often use sculptures as references, but the true masterpieces are the ones that I can see in a museum, then go home and still vividly remember their poses. By searching for the reasons a sculpture leaves such a strong impression—perhaps its vigor, romanticism, weightiness, the suggestion of skin—I can begin to see which aspects I need to put into my drawings.

When posing your characters, you must take care to correctly capture the human skeletal structure and movement. Rather than manipulate a character's limbs at random, you must understand how the parts of the body connect and flow—how a person's legs move when their hips jut out, where their knees are positioned, how their shoulders move. If you draw a character simply standing, yet their elbows and waist are misaligned, that pose is not likely to leave an impression.

In *JoJo*, I push the limits of the human body with my characters' poses. By amplifying the signification of poses to the extreme, you can achieve a form free of all extraneous elements, like with Myron's famous sculpture, *Discobolus*, and its unusual, captivating, slightly bent-over and angled pose of an Olympic athlete about to hurl a discus. Whenever I view what are considered the great sculptures, I'm struck by the impression that those ancient Greek and Roman sculptors chose and carved those poses as if their very lives depended on it.

Make the Invisible Visible

I'd like to take a moment to talk deliberately about what visual art is. I believe that the fundamental role of art is to make the invisible visible. Whatever the artist wants to express, be it love, friendship, justice, or something else—these are not things that can be seen by the eye, and the artist must turn these invisible ideas into a visible picture.

Music is also invisible, but musical notation makes it able to be seen, and I've heard that a score that is beautiful to the eye will make pleasing music. I find this connection between the visible and invisible deeply fascinating. Signification is also by definition a way of drawing the invisible. Characters like Doraemon, Mickey Mouse, and Anpanman communicate friendliness and kindness through their images. And when many drawings are put together into a manga, the manga as a whole can convey that which can't be seen.

Katsuhiro Otomo's *Domu: A Child's Dream* provides an unforgettable example. *Domu* is a manga involving extrasensory powers, and in one scene, an older salaryman is seated on a park bench while listening to a radio, then the next panel casually cuts to show the radio bursting apart. I could clearly sense the unseen energy of that powerful destructive force. I still remember how impressed I was that a manga could depict such a thing. It was amazing.

The incredible thing that Katsuhiro Otomo did was to precisely draw each tiny part of the exploding radio in detail, rather than exaggerate the parts into something fake and easy. The common method at the time would have been to punch it up by drawing the exploded bits as rough, jagged shapes or something to that effect. Such drawings may seem like they would be more dramatic, but they lack realism. That's what Katsuhiro Otomo's realistic and convincing drawings taught me.

Hamon and Stands Make Supernatural Powers Visible

Those experiences led me to pursue the question of how I could create drawings that made the invisible visible. What I came up with was the *Hamon* (ripple). If a character punched a frog, and the frog

was completely unharmed, but the rock beneath it cracked open, that image would convey the power of the character's supernatural abilities. When I came up with that idea, I felt the thrill of success, but it wasn't long before my editor told me he was tired of Hamon.

I concluded that he had likely grown tired of the effect because it was only one kind of thing. I concluded that a broader assortment of powers wouldn't have that same pitfall, and that's how Stands were born. Stands are personifications of a user's inner energy; while Hamon made superpowers visible, Stands took the next step and made them into characters.

I've used Stands to make many things visible: moving quickly, moving far, being transported far, moving slowly, placing curses, stopping time, moving through time, reading people's inner thoughts, seeing the future, becoming electricity, becoming a magnet, ignoring gravity, aging rapidly or slowly, taking souls, healing/repairing, and more. There are still many strange phenomena I haven't yet made visible, and I intend to continue challenging myself to find ways to draw them.

Don't Try to Fake It

When an artist gives form to something invisible, their state of mind will be reflected in the picture whether they're aware of it or not. A drawing of a single coffee cup will not be a purely objective re-creation of the real-life object, but will portray the artist's self. Even pictures taken with a cell phone camera reveal the picture taker's personality. Humans seem endowed with an ability to both express and detect those intangible qualities.

Despite going through a process of printing and mass production, manga is no exception, and since a mangaka's mental state when

drawing will always be revealed to the readers, those emotions are of critical importance. Any attempts at fake sincerity will be in vain. The readers will always see through to the truth.

Some artists fly through their drawings and think they're hot stuff, but I don't think that's the way to be. It's not about whether their drawings are good or not; what leaves a bad impression is the attitude of putting on the appearance of trying hard when in fact they aren't. You see it in kanji calligraphy, too, where there's a difference between something made to look skillful and something written with skill. Those kinds of artists are the only ones who think they are coming across as skilled, while the fact that they aren't is evident.

But regardless of what the artist may think, manga art must not be drawn hastily, or in a haphazard manner. Even when running out of time against a looming deadline, the artist must draw with care. That is the number one rule. Even if some of my art may appear coarse at a glance, if you look at the original, you would see I approached it with care. As long as I am a professional, I won't ever phone in a drawing, and to try to do so and hide it would be inexcusable.

Preserve a Moment for Eternity

Another important thought I hold while drawing is the desire for the art to be remembered by the reader. Whenever I draw, I'm always trying to create an image that will leave a deep and lasting impression on the viewer, so that they may see it again years later and think, "Ah! I remember this picture!"

That may be why I love still pictures. A good number of mangaka say they wish they could see their drawings in motion, but that doesn't interest me much. What's important to me is that each drawing is complete.

The composition, the color tone, the characters' expressions, the line work—everything that comes together to form a picture can create an impact in a still image that moving images just can't match. What's wonderful about still drawings is their ability to create what I think of as eternal moments—what would otherwise be fleeting moments captured within particles of pigment. Everything—a person's entire life, outlook, and beyond—can be condensed into a single drawing. It's an incredible thing.

Just as Leonardo da Vinci painted the *Mona Lisa* over decades, I feel that a picture could be drawn for an eternity—at least until the artist is made to stop. That the *Mona Lisa* was never finished is what makes that smile so enigmatic, but no matter how many times one looks at that smile, it never becomes boring. The process of creating a drawing is to allow it to grow and mature, and therein lies the appeal of a picture. When I'm working on a drawing, I sometimes wish I didn't have a deadline so that I could keep working on it forever.

Paintings like the *Mona Lisa* and others by the great masters of the Renaissance can be viewed for hours, but I also think that can be applied to some manga art as well. Through the work of drawing, artists can integrate many different kinds of worlds into pictures, which readers can read and reread, sometimes stopping to stare at their favorite scenes. I find that form of enjoyment to be closer to paintings, sculpture, and ceramic art than it is to the fluid pictures of anime or movies.

Why I Persist in Drawing in Analog

These days, many artists draw with computers, and I'd estimate that 90 percent of coloring is now done that way. From a technical standpoint, digital drawing has advanced to the point where it's no longer

inferior to analog drawing, and it even has the advantage of not requiring as much training. Digital coloring can be performed on an ink-and-paper drawing with the help of a scanner, but doing the whole drawing from start to finish on a computer provides enough benefits—including easier coloring and the ability to send the data as-is straight to editors—that it's only natural for some artists to choose an all-digital approach.

The reason I still do everything on paper is that analog can always be made digital, but digital can't return to being analog, and I figure if that's the case, then analog is superior. *JoJo*'s 25th anniversary exhibition was possible because I had worked in pen and paper.

When I finish one of my manga, I want to experience the same emotions as viewing art in a museum. In other words, when I see the real thing, I feel something stir in my chest. The presence of that emotional response is important to me. When I was a child, a bookstore in my home of Sendai was selling *The Legend of Kamui* and had a personally signed autograph from its creator, Sanpei Shirato. I don't believe that seeing it would have been as thrilling—"Wow! Look at that!"—had the autograph not been the real deal. Now, this might be nothing more than a matter of perception, but to me, an image printed off a computer screen is merely a copy, and the feeling I would get by completing it wouldn't have that same emotional impact that I get from original art.

I Want to Hold on to That Live-Performance Feeling

This might be a little hard to put into words, but when I draw using physical media, I almost feel like I'm caressing the drawing, and I start to feel affection for my characters. That even applies—given enough time—to characters that I don't like when I first create them.

Sometimes I'll even cry when they die. Since I don't work in digital, I can't know for sure, but drawing directly with my hands is what leads me to such unanticipated experiences.

When it comes to coloring, a digital colorist can try a color, decide it doesn't work, then immediately try a different color, but when you do it by hand, and you ever think something like, "Blue would have been better than red, after all," you have to redraw the entire picture from scratch, which makes revision not particularly effective. When you draw by hand, you get the tension that comes with having no takebacks, and that live-performance feeling of betting everything on the moment.

Because I want to hold on to that "live" feeling, I don't redo any picture I've drawn except under extreme circumstances. In music, live jazz is created within the tension of not knowing what will happen in the performance, and I believe that same idea can also apply to visual art.

Visits from the God of Manga

Sometimes, maybe influenced by my physical state that day or some chemical change beyond my understanding, my drawings go better than I had anticipated and make me think, "This line is really great!" or "I nailed the curve of that cheek! It's perfect!" When those drawings come like unexpected presents, when my art is better than me, I think that maybe it's the god of manga descending to visit me.

The feeling I get when I surpass my own ability might be what makes drawing so enjoyable. When I'm drawing rough poses, sometimes I only need to draw it once to find the line I want, but other times I try many different curves before suddenly striking the right one, and that moment of elation makes me want to thank some

higher power. When I'm coloring, the colors can diverge from my original plans; I might picture something as being blue, but when I try adding a little gray, I think, "I like this darker color!" Such happenstances might be beyond explanations of reason.

I admire the Italian technique of fresco painting. In that technique, wet plaster is pigmented, and when the plaster dries, there's no redoing it, and the image is locked away in semi-permanent form. I think what makes these works so deeply impressive to the viewer is that they were created not only requiring skill and technique but with that live-performance tension that comes from the pressure of knowing that a mistake will mean failure. It's the same with manga; when you have one of those moments where you think, "I made great drawings today!" your readers will undoubtedly react favorably as well. You should recognize the benefits of digital media, but if these elements are important to you, you might want to work in analog instead.

CHAPTER 6

WHAT SETTING IS TO MANGA

What Is a Setting?

Settings, another of the four fundamentals of manga design, must also be approached with care.

A manga's setting is the world that unfolds in your manga. It is where you want to place your characters. These worlds come in many forms—fantasy, science fiction, action/adventure, sports, school life, horror, and so on—but whether they are of the fantastical or the everyday, worlds built within manga are different from our own, and readers want to immerse themselves within those worlds.

Many aspiring mangaka tend to overlook this point, but the way a manga's setting is drawn directly connects to whether the readers will take to a manga. If a large number of readers want to engage with the world of a manga, that manga is on its way to becoming a hit.

If we say that a manga creator's foremost concern is that of creating characters, then readers are primarily motivated by the desire to be immersed in that creator's worlds. Wishing to encounter certain characters and being interested in the story are secondary concerns.

Readers Want to Be Immersed

With this being the case, a manga's setting plays a vital role in attracting readers.

A setting is an alternate reality, and as such it must be grounded in realism; if you create a world haphazardly, the readers won't achieve immersion and will likely lose interest in reading your manga. Even if the world is fanciful, the setting must exist as a whole and structured entity within the mangaka's mind, and it must have an inner logic. Only then will readers become absorbed in the events that unfold within that world.

People read manga because they want to experience unfamiliar worlds—sometimes ones that can't exist in our reality—like a frozen world, to give an example. They want to follow the adventures and great drama within the imaginary world of a manga. Yukinobu Hoshino's science fiction manga are exemplars of grand, fantastical worlds created with detail and realism. Even his spaceships are grounded in scientific theory and drawn with authenticity, as if they truly are floating through the weightlessness of outer space. If the ships had been simply drawn according to whim, they would have felt contrived, and readers would not be able to become immersed in the manga's world.

At the same time, readers are also interested in worlds that reflect their familiar daily lives. They enjoy the fiction—similar to their own lives but not the same—that only manga can provide. Representatives of this type of manga include *Sazae-san* and *Kochikame*. In *Sazae-san*, her family's home is established in detail, including the layout of the rooms and the locations of their possessions. In *Kochikame*, the area around the branch office is depicted in such meticulous detail that it creates the illusion that Ryo-san actually exists there. Because

these worlds are portrayed so convincingly, readers desire to become immersed in them.

Where *Baoh: The Visitor* Failed

One manga from my early career was called *Baoh: The Visitor*. It was during the time I was working on that manga that I began to realize the importance of setting. For example, an evil organization serves as the antagonist, and I came to understand that I couldn't go anywhere with the story without first knowing how they acquired their funding, and the kind and locations of facilities they controlled.

But I also have a bitter memory from my creation of *Baoh*'s setting. The protagonist, Baoh, is a boy who can turn into a monster, and the manga opens with a scene that takes place on a research train where Baoh is being experimented upon. The train runs along the Sanriku Coast, and in real life that railroad hasn't been converted to electricity and still runs diesel railcars. I've visited the area and I knew that it was a diesel line, but for the purposes of the story I wanted Baoh to be electrified by high-voltage power lines, so I added in overhead power lines and drew the scene with Baoh running atop the train.

After the story was published, readers wrote in to notify me that that route ran diesel trains, not electric. Even worse, I drew it with a double track, when in reality it is a single-track railway; I had drawn two mistakes at the same time. The readers who noticed this were likely never able to re-enter *Baoh*'s world. I had committed the grave failure of losing readers.

What I ought to have done was not to force a diesel railway into an electric one, but rather use a different railway, or devise some other way of electrifying my character. I learned my lesson and took

it to heart: any time I create a setting without putting in the proper effort, my readers will catch on.

Only a Master Can Rely on Mood

On the subject of failures, I had an abandoned project about a year before my professional debut. I had titled it *Sunaarashi* (Sandstorm). It's a lost work—never published and with the original art now gone—but I recall the story was about a boy going to save his sister from a strange sandstorm in the desert.

That manga failed because the storm-as-antagonist lacked punch. No matter how unusual the phenomenon may be, a sandstorm just doesn't have enough going on to fill the role of the antagonist. This resulted in a manga with more mood than story, and in the end I couldn't make it fit the battle manga structure.

Sandstorm failed because I focused too heavily on mood, but had I been a better artist at the time, my work might have found acceptance. I think that's the defining characteristic of mood-based manga—if you're not an incredibly skilled artist on the level of Akira Toriyama or Katsuhiro Otomo, the manga won't come together.

Some shojo manga—manga aimed at a teenage girl audience—like *Wata no Kuni Hoshi* (The Star of Cottonland), are able to create a wonderful atmosphere. But those manga can only succeed when at least some major element of the work is far beyond that of their peers, like the creators being exceptionally emotionally perceptive or the setting being just right. In other words, a focus on mood comes with a great risk of failure, unless the mangaka is extremely gifted in some way—whether that's in drawing ability or world building or something else. Only a handful of masters can succeed while pursuing mood above all else.

Furthermore, because shojo manga aim for that softer kind of mood, they might be able to get away with art that isn't quite so meticulously drawn. Readers of shonen manga, on the other hand, demand more detailed art, which makes the hurdle for a successful mood-based manga that much higher.

Be Thorough in Your Research

Let's return to the topic of how to create a setting. When you're creating a fictional world—to put it in the terms of *Star Wars*—you need to know what's going on inside the Death Star. In other words, in order to convey a setting, every image, down to an unassuming landscape, requires research into every detail. Sometimes, your answers will come from the needs of your manga. Let's say you've decided to draw a train. You shouldn't just draw any train. There must be a reason you're drawing one in that picture; what kind of train does it need to be to fit that reason?

Getting the time period right is a major point. If your manga is taking place in 2001, you need to know what kinds of cars were on the road before you draw them. If you draw a current-model car in a manga that takes place in 2001, readers will notice it straightaway, think, "This is a sham," and will lose immersion in your setting. Some details might never become a factor—you may or may not need to draw a contemporary cell phone, for instance—but broader topics, like what was trendy, what songs were topping the charts, or other such facts all form a level of basic knowledge you need to acquire.

Say you're drawing a hospital in your manga. Knowing what else is in the building behind the waiting and examination rooms will lead you to create an authentic setting. You may be thinking that's a lot of unnecessary effort, but the more thorough your research is, the

firmer the setting and the stronger your confidence will be. In order to draw it right, you mustn't slacken in your research.

How to Create a Setting

Now, let's move on to how to create your settings. I'm going to list some basic examples, as they come to mind, of where you should focus your attention and what areas need consideration and research to flesh out your setting.

When drawing an organization:
- Who is at the top of the organization, and what is that person like?
- What are the goals of the organization?
- What is its source of funds/income?
- What kinds of special privileges/permissions/permits does the organization hold?
- How it was formed and who was the founder?
- Roughly how many members are in the ranks?
- What kind of internal rules are in place?
- Do they have some kind of distribution network?
- How are responsibilities divided? Are there divisions/groups/departments?
- Do they have ties to the underworld? Do they engage in foul play?

And so on...

When drawing a historical time period:
- What is the society like?
- Who is the ruler?
- What is the religion?
- Fashion
- Architecture
- Interior design
- Food
- Currency
- Geographical features
- Current affairs

And so on…

When drawing geography:
- Topography, guide books
- How are places located in relation to each other? (North, east, south, and west)
- What kind of roads are there?
- What kind of railroads are there?
- How far away is the nearest airport?
- What are the local industries?
- Is there a seaport?
- What kind of hotels and restaurants are there?
- Other local information you'd look up before vacationing

And so on…

When drawing sports:

- Rules

- History

- Uniforms for players and referees

- How many players and referees are there?

- Is someone paying everyone's salaries?

And so on…

When drawing a sushi chef:

- How does the chef go about sourcing fish in the morning, prep work, and cleaning?

- How does the chef handle cleaning up after closing time?

- Hand motions and amount of force used when forming the sushi

- Preventative measures against food poisoning

- Seasonal topics

And so on…

When drawing a love story:

- What is the romantic interest's job?

- How much does he or she make?

- What does he or she wear?

- How does he or she behave (including etiquette)?

- What are potential locations for dates?

And so on…

When drawing science fiction:
- What is the infrastructure like?
- Who is the head of state?
- What is the fashion like?
- What types of flora exist?
- Do the animals have sexes? How are they born?
- How do the robots move? What are they made out of (including qualities of the material)?

And so on...

Some Things Can't Be Researched Online

As you can see, countless considerations go into creating a setting. You may be able to get much of what you need by researching online, but sometimes you just have to go do the research in person.

Because of the time and effort involved, going in person is far more difficult than referring to research materials as you draw. But when you go to a location in person, you will find a real understanding of what you need for your drawings, and you might find the inspiration for new ideas.

Quite often, you will also find that a location is different in person than you had imagined it would be. Two areas may seem close to each other, but when you walk the distance, it is much farther in reality. A building that seemed enormous in a photograph may actually be underwhelming, or a location that seemed extravagant might surprise you with its tawdriness. Therefore, if you want to draw things right, I recommend experiencing them for yourself as much as possible.

After I started making *JoJo*, I got into the habit of visiting the places

I was drawing whenever I could. Even for the third arc, *Stardust Crusaders*, I went to every location along the story's route (excluding the more dangerous areas), up to and including Egypt. I visited Egypt three times in total, though as I don't handle non-Japanese foods very well, I brought with me instant ramen and bottled drinks. When I went out to do shopping, I'd run into vendors who tried to charge me prices inflated by a factor of ten, or even twenty, without batting an eye; even though I was already aware of that practice, I was able to learn so much more by experiencing it myself.

I set the climax of *JoJo's* fifth story arc—*Vento Aureo*—in Rome, and performed extensive research in order to faithfully portray the city. Before going there in person, I studied how the city was built in depth—the geography and history, what kind of buildings were there, what the infrastructure was like, and more. I read travel guides and searched for pictures and committed as much of them as I could to memory. Then, when I had exhausted my research, I traveled to find the things that weren't in the research—the things I wouldn't know I needed until I found them. As a result, the Rome I drew captured the real sights of the city—from the buildings to the traffic signals and signs, and the side streets, and more.

If you were to go to Rome and trace the path taken by the hero (Giorno), his allies, and the villain Diavolo from the Colosseum to the Tiber, I think you would find that I accurately captured the real distance. The map in a guidebook can help you gauge a distance, but looking at a map will always leave something unsaid that will pique your curiosity; those answers will only be found in person. Most people assume you can now find anything you need to know on the Internet, but many details will escape your awareness—for instance, the markings of the police cars, the shapes of mailboxes, the uniforms worn by the mail carriers, what the toilets are like, and so

on—unless you go observe the location with your own eyes.

The Sense of Distance: Japan versus the American Midwest

JoJo's seventh story arc, *Steel Ball Run*, involves a race across America, but I knew that undertaking that journey by myself in one single trip would have been impossible. Instead, I split up the research into three sections: from the West Coast to the deserts, from the Great Plains to the Mississippi River and Chicago, and to the finish line in New York. Each region possesses its own culture and is home to different types of people.

Without going there for yourself, it's impossible to comprehend the feeling of scale in the midwestern United States, where the scenery stretches on forever and unchanging. The feeling of distance there is nothing like in Japan. Say, for example, an enemy is approaching from afar—at such a distance that escape would be trivial in Japan. In the Midwest, the open landscape remains identical from one hour to the next, and I was struck by the real sense that I could never make an escape from such an adversary; there was simply nowhere to hide. I was able to put that experience to good use when it came time to draw the manga.

Travel there is mostly done by car. When you drive across those vast plains, the scenery is mostly devoid of any ups and downs, and is dotted only by the occasional town with nothing to claim but chain stores, seemingly little to provide amusement aside from watching movies, and you hardly ever see anyone else about. Rather than inspire thoughts of enjoying nature, it felt empty and lifeless and made me wonder if there was any fun to living there at all. A kind of atmosphere hung over these places that felt rich for suspense. By

connecting these real experiences to your settings, you can add real depth to your manga.

There is one problem that only comes up if a mangaka's career is going well, and that is that keeping up a serialized manga requires great amounts of time and stamina. Missing a deadline will begin to exact a mental and physical toll, and once you finish your assignment and it comes time to face the next week's planning meeting, you'll already be exhausted in mind and body. Under those conditions, continuing to make good manga is not possible. If you can't find time to do this kind of research, or even to watch movies or read books or other activities to help find ideas, you'll wither as a mangaka.

This is as basic a concept as it gets, but it must be said: nothing is more important than meeting your deadlines and establishing a pace and rhythm to your work.

Don't Draw Everything You Research

No matter how much research you do, and how much you experience for yourself, you're never going to draw all of it, and you mustn't let the establishment of your setting become the focus of your manga. What readers want to see are your characters' actions and their fates, and you have to remain on guard against spending excessive time on setting the stage.

The worst is when a manga goes on and on about the setting at the very beginning. This would be like a manga about a sushi chef starting out with: *The sushi chef wakes up early. He goes the fish market at such-and-such hour. When he first arrives at the fish market, this is what he does.* And so on. When you spend too long establishing the setting, the readers will become impatient and think, "Just start the story already!" For another example, if you spend too much time

CHAPTER 6

showing everything your characters wear, as opposed to having those characters do things, the readers will similarly respond, "Enough with the clothes!"

The setting should be incorporated into your characters' actions and dialogue. If you integrate the setting with the obstacles your protagonist faces, that setting will come across to the readers. You can also use something that seems wrong and out of place—like putting a plant from northern America in a desert—as important foreshadowing. If you can draw the setting with relevance and cohesion to the story, you can fully communicate the setting to the reader without having to devote needless exposition to it.

Because manga has the capacity to express multiple concepts at the same time, the setting can be combined with other elements of the story, although being successful at it requires intent and technique. When you read other manga, you should also study what you're reading; be on the lookout for how the mangaka incorporates setting. With practice, you'll begin to get a sense for it.

After the Setting Is Complete

The setting becomes a world in which the readers want to become immersed, but it is also a world in which the creator wants to become immersed. When a manga primarily focuses on its setting, I believe that is because the creator deeply wants to be immersed in that world.

But the problem faced by setting-focused manga is that once that setting is fully fleshed out, the creator's desires are satisfied. If the goal is to create a complete depiction of that world, and the depiction becomes completed, the creator will need a new goal to top the previous work.

But the more magnificent the completed setting, the harder it is to

land upon a setting that can surpass or even match it. *Akira*'s setting was so masterfully created that I still don't think it has been bested to this day.

Undertaking that challenge is of course an option available to you, but any creator of a setting-focused manga should only go down that road if they're prepared for the difficulty ahead.

If you want to further develop an already completed setting, using new characters may help you succeed, like how the prequel *Star Wars* trilogy found a new protagonist in Anakin Skywalker, who would become Darth Vader. Characters are always capable of inner growth; they keep on growing and never reach a completed state. As I previously wrote in the chapter on the four major fundamentals of manga structure, the royal road to creating manga requires intimately connecting all four fundamentals, and not just setting alone.

CHAPTER 7

ALL ELEMENTS CONNECT TO THE THEME

The Theme Connects the Four Major Fundamentals

In the chapter on the four major fundamentals of manga structure, I proposed that each element influences the others, and it's the theme that unifies and connects the characters, setting, and story.

This isn't limited to manga, but applies to movies, novels, and television shows alike. Any superior work is backed by a strong theme. A theme is not something expressed directly, but is something akin to one who rules from the shadows.

To understand the connection between setting and theme, you need look no further than the movie *Frozen*. Some say that *Frozen* was such a blockbuster hit because the heroine was a strong, modern character, but I think the biggest factor was its white, cold world locked away in snow and ice. The theme of the protagonist's loneliness could only have been expressed in the frozen setting, and contrasting the warmth of the sisters' love with the frigid cold provokes a strong emotional response. If that same story were set in a desert or a science fiction setting, the movie would have communicated something completely different.

To use an example from manga, I think that the theme of *Mushishi* is its depiction of the ethereal, spiritual mood that dwells in

nature. Shigeru Mizuki (*GeGeGe no Kitarō*) would likely draw the backgrounds as far more lifelike, while Kazuo Umezu (*Cat Eyed Boy*) would draw the characters in greater detail. But I suspect that *Mushishi's* creator understands that in the context of the mood-centric theme, there's no need to draw everything in detail. I'd even say that the less detailed drawings reinforce and help express the mood.

Don't Let Your Themes Become Muddled

Themes, in another sense, are how the creator views the world, and what he or she considers ideal ways to live. The author's goal is to embed them in the root of the work and to endeavor to keep them firmly in place.

For example, *Kochikame's* consistent theme is the depiction of everyday commotions created by a childish policeman. The mangaka never attempts to send Ryo-san out on an adventure away from his post in Kameari just because adventure manga were popular at the time. At most, Ryo-san goes on a vacation every now and then, but even then, the stories deal with the day-to-day; the greatness of *Kochikame* is that its theme has remained consistent throughout the decades.

Let's say you create a soccer manga, and what you truly want to depict are the friendships shared by the young players, but your manga doesn't find the popularity you had hoped. Your editor comes to you and says, "What's popular right now are manga with detailed depictions of complex soccer strategies, and you need to make your manga more about that." If you let your theme of friendship become muddled, your manga will fail. If that happens, you might lose confidence in your manga and never be able to put it right again.

If you're ever in that situation, you need to think long and hard

about what you want to draw—in this example, whether you want to draw a manga about friendship or about the strategy of soccer— and keep that theme firm in your heart. Whether or not you can succeed at that depends on how strongly you believe in your theme; this might be a difficult task for those who are still lacking in life experiences. When a theme becomes muddled, it's a sign that the mangaka's own approach to life is unsteady. Until that is made firm, the mangaka is unable to hold to a persistent theme.

If, in the end, the theme just isn't working out, scattershot attempts at making changes won't help. All you can do is start from the beginning. Shore up your theme, seek new avenues of development, and find your way through your situation.

Themes Reveal the Creator's Philosophy

Because ways of thinking change over time, it follows that some themes will reflect the thoughts of that time. Furthermore, themes exist in countless varieties, each depending on what the author wants to create. Even when the overall goal is the same, each creator has a distinct point of view, which will result in the theme taking different forms. If a mangaka wants to portray police corruption, that might take a direct form, or it might focus on the friendships that develop within the corrupt organization while depicting its ugliness and folly, or it might follow any other possible directions.

For another example, take a mangaka who wants to draw erotic work. What actually *is* erotic will depend upon the mangaka.

- Type of figure, type of face
- Behavior

- Gazes
- Purity or carnality?
- Full of life?
- Full-figured?
- Skinny?
- Radiant skin?

And so on…

As you can see, the erotic contains many facets.

Those definitions become directly connected to the art; that is, how the mangaka will draw women. This includes the thickness of the line work, but it goes further than that. Drawings aren't only composed of the lines, but will also reflect the artist's subconscious thoughts. To give a few examples:

- Kō Kojima's brushlike lines
- Hisashi Eguchi's modest subjects
- George Akiyama's use of calligraphy pens to vary line thickness when drawing skin

A Paean to Humanity: Theme as a Product of Chance

JoJo's theme is a paean to humanity—in other words, an affirmation that mankind is wonderful. When the characters in *JoJo* are faced with adversity, they find a solution and forge a path onward by their own abilities and never by some convenient coincidence. No god intervenes to save them and no magic swords suddenly fall from the

sky and into their hands.

To be honest, this idea of a "paean to humanity" was not a product of deep consideration, or of wrestling over what I wanted to draw. It was a phrase I came up with lightly. I was told to write something for the inside flap of the first graphic novel, and I just happened to get the idea to write about the magnificence of mankind. At the time, I didn't mean much more by it than to say, "I'm not going to write a mecha manga where people fight using machines." But as I've continued to write about that theme over the years, I've come to see it as a subject with great depth.

In hindsight, I can see what led me to that theme. When *JoJo* was just starting to be serialized, my grandfather passed away, and it made me think about how people die, but that some part of us is left behind to be passed on to the following generations. *East of Eden*, a work I deeply admired, also dealt with the theme of connections across generations, and at the time, everyone was talking about *Roots*, the American drama series. On the surface, the series appeared to be about slavery and racial discrimination, but as I watched it, I thought it was at heart a story about a family. When I started *JoJo*, I wanted to write about a battle between good and evil, but these influences led me to make my series about passing the torch.

If I had never come up with a paean to humanity as the theme, *JoJo* would have turned into something different. I might even have found myself unable to find ideas to get my characters out of the dangers in which I put them, thereby bringing my series to an early end.

The Mistake of Choosing a Theme Based on What Will Sell

I've already touched upon this, but it bears repeating: without exception, a theme should reflect the creator's life. When deciding upon a theme, the one thing you absolutely must not do is choose one that doesn't interest you simply because it matches what's selling. Let's say you take a popular theme for your own work. When the trend passes, you'll be left with a theme that doesn't interest you, and as you begin to question why you're writing about it at all, your manga will hit a wall.

The most important questions for a mangaka are "What do I want to draw?" and "Why do I want to draw it?" A brilliant person could read this book and use my advice to custom-tailor a manga so that every element is optimized for popularity and appeal, and that mangaka might possibly come up with a calculated hit. But that will only work for a short time—maybe three years, at best. From what I've seen and heard, that's about how long it takes before intellectual fatigue sets in. Then, when the manga's creation becomes rote, the readers will notice.

If a mangaka draws out of a desire to have a hit, and the manga successfully finds a large audience, the creator's ambitions will be fulfilled, the passion to create will wane, and the manga will arrive at a dead end. The mangaka will begin searching for a new path, and be beset with doubt. If you view creating manga as a temporary business endeavor, that result might be good enough for you, but if you want to pursue the royal road to being a mangaka, then I urge you to avoid that way of thinking.

If you find a theme that interests you and connects with you on a personal or emotional level—even if you think that theme may be

too dark to sell—you should resolve to create your manga around that theme. Your manga's success will not depend upon a seemingly salable theme. Whatever your theme is, if it feels right to you, and you layer upon it characters and a story that move you, it will undoubtedly be an interesting work, and one that readers will welcome. I wish for anyone who wants to become a mangaka to believe that which they feel is right, and to follow manga's royal road with determination.

IMPLEMENTATION, EXAMPLE 1

THE PROCESS OF MAKING MANGA

How to Find Ideas and Create Panel Layouts

Where Ideas Are Found

Now, I'd like to build upon my previous explanations by outlining, in specifics, the process for creating a manga.

Each mangaka has their own process, but mine goes like this:

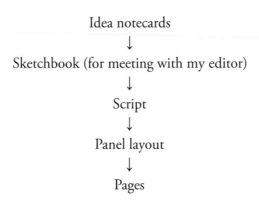

Idea notecards
↓
Sketchbook (for meeting with my editor)
↓
Script
↓
Panel layout
↓
Pages

Every manga starts with an idea. That being the case, I'd like to start this section by discussing where ideas are found. In this, too, each creator has their own method, but the one universal is that ideas

come from a place deeply connected to the creator's life, experiences, and way of thinking.

I believe that ideas should come from something closely connected to the artist's life, whether that be a personal interest, trouble in romance, a desire to travel to some foreign country, nearby events, or anything else.

When I first started submitting manga in high school, the world was still vast, with many places unknown to me. I admired stories set in mysterious locations around the world, whether true, as in the adventurer Naomi Uemura's travel writings, or imagined, as in Jules Verne's *Around the World in Eighty Days*, and I desired to create stories in similar settings. Musically, I'm also drawn to progressive rock and jazz fusion, which combines influences from various cultures around the world, and that has also likely been an influence in the kinds of stories I write for *JoJo*. I've always been intrigued by the idea of supernatural powers, and I've often speculated about how, if they were real, one would go about scientifically proving them. I think that's what led me to come up with *JoJo*'s Hamon and Stands.

Take Interest in Other Viewpoints

I keep the practice of always writing down the things around me that pique my interest. But I don't write them down then and there. Waiting sometimes means that I forget the thing that interested me, but that doesn't bother me—anything that I would forget after a short span of time must not have been that interesting. If something is worth remembering, I'm confident I will remember it after a time.

The notes I keep broadly fall into three categories:

- Things I like

 For example: If I see a movie that has a scene I particularly like, I'll make a note of it after. But I don't just write that I liked the scene; I analyze it for the parts that I liked, and why I had a positive reaction.

- Opinions contrary to my own; events that gave me doubts; people I don't understand

 These encounters can be a rich source of ideas, so when you run into them, you mustn't let the opportunity escape. Rather than shut out opinions and occurances that run counter to your own understanding, try to be more analyical about them. Why does this person think that way? Why is this happening? When I heard this, what did I think about it? By asking these kinds of questions, you can learn about perspectives other than your own. If a subject or situation doesn't interest you, or doesn't match your tastes, but you can come to understand why other people like it, you can expand your world and discover new sources of ideas.

- Events that provoke emotional reactions: frightening, humorous, traumatic

 By considering the reasons why an event made me feel scared—or made me laugh—the experience can lead to new ideas.

Ideas Are Limitless

I'm sometimes asked, "Do you ever run out of ideas?" but I don't believe that ideas ever run out; I think a creator's curiosity can run out, and then the ideas stop coming. Because good ideas come from one's life and experiences, losing interest in the world means losing the ability to come up with ideas.

If you're always able to maintain interest in something, and you can keep your antennae poised to pick up on—and react with openness to—the occurences around you, you won't run out of ideas. The key word there, and what I hope you'll make efforts toward, is "openness." You mustn't restrict your attentions to only the things that interest you; that sort of conceit must be avoided.

If I ever find myself struggling with finding new ideas for a story, that will be the day I quit being a mangaka. I count myself fortunate that my idea notes continue to flow and that I can continue being a mangaka. I used to be concerned that I would run out of energy, and that I would probably retire once I hit fifty, but as long as I can remain curious and interested, I'll keep on drawing a little while longer.

Meetings with Your Editors

When the time comes to begin drawing a manga, I go through my idea notes, select the ones I think I can use, and bring them to my editor.

When I have these meetings, I bring along a sketchbook to take notes. As an example, I'm including notes from my first meeting for *JoJolion*. This way, you can get an idea of what I write down.

The basic idea behind *JoJolion*'s opening chapter is that a young

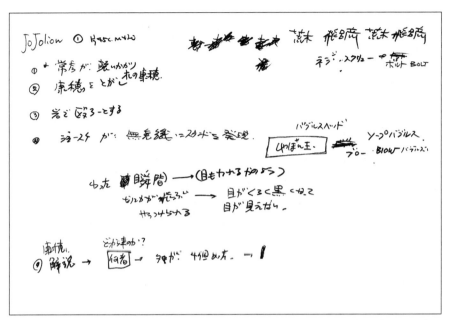

Idea notes for meeting with the editor.

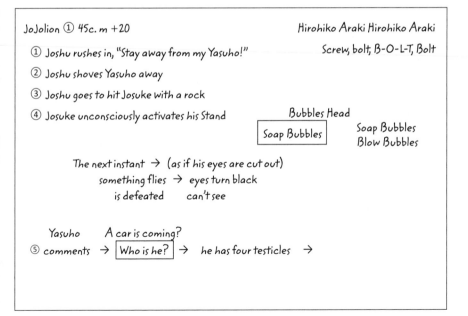

JoJolion ① 45c. m +20

Hirohiko Araki Hirohiko Araki

Screw, bolt, B-O-L-T, Bolt

① Joshu rushes in, "Stay away from my Yasuho!"

② Joshu shoves Yasuho away

③ Joshu goes to hit Josuke with a rock

④ Josuke unconsciously activates his Stand

Bubbles Head

Soap Bubbles

Soap Bubbles
Blow Bubbles

The next instant → (as if his eyes are cut out)
something flies → eyes turn black
is defeated can't see

Yasuho A car is coming?
⑤ comments → Who is he? → he has four testicles →

man with amnesia reclaims his identity. The page I'm including are the notes for what I wanted to include in the chapter.

The basic flow of the story is as follows:

- Joshu rushes in, shouting, "Stay away from my Yasuho!"
- Joshu shoves Yasuho out of the way
- Joshu goes to hit Josuke with a rock
- Josuke subconsciously activates his Stand

Beneath those notes, I wrote ideas for Josuke's "soap bubble" Stand. In the upper right, where I wrote "screw, bolt" were ideas for Joshu's Stand, although it doesn't appear at this time in the story. The part at the bottom where I wrote "Yasuho comments" are notes on how the chapter will conclude.

I bring these notes with me to the meeting, and as I talk with my editor, I revise and add to them. Additions come through our exchange of ideas, and if something seems weak, I'll rework the idea, which may result in needing to perform additional research. The results of the meeting determine whether or not I'm able to immediately proceed to the next step of my process. If I can't find suitable ideas during the meeting, our discussion will eventually reach a standstill, and I won't be able to move on to the next step.

Write a Script: Envision the Dialogue and Panel Layout

As for what the next step is, that will depend on the mangaka. Once I get through the meeting with my editor and receive the go-ahead,

車椅子　ちっ 違うっ!!
　　　　　　説明させてっ!!
常秀　あなたの!!　待って この人は!!
　　　（無意識の　常秀）
　　　なだめする 車椅子を おしのける 人々ガリっ!!
　　　なだれる 車椅子

　　逆の少年　目を覚ます　バテリッ
　　逆の少年
　　なだれている 車椅子

　　若きかぶる 常秀
　　少年向かう　ガシ　イ!!　組立一 ガードする

　　　常秀
　　　少年
　　　常秀　少年の手をつかむ
　　　　　　てめえる　クギィィ!

　　少年・ビックリする（ちく）

　　　常秀の　蹴リ　すデイへ　入っ!
車椅子　少年地面ル 前ける
常秀　きゃあああああ ああ ————
　　　　　　　　葉のアザ
常秀　みれ ———— 縁き切ったあああ
　　シュギー ン ラララっ もう駄目だ　気持ちを おさえられない

An outline before panel layout. Only dialogue is written.

I write a script.

For my scripts, I write one page's worth of dialogue per sheet of composition paper (see page 183). The total available drawing area for each manga is fixed and of limited space. Each page is 270 mm tall by 180 mm wide; multiply that by the number of pages to be published. Everything you want to draw has to fit within that space, and when I write my script, I plan out and allocate my use of that space.

JoJolion is a serialized manga published in a monthly magazine called *Ultra Jump*. Each chapter is allotted forty-five pages, which I typically consider in groups of four to five pages. I divide the story into these smaller sections based on the amount of story beats and the flow of the plot, giving the most important sections the most page space. Through experience, I've gained the understanding of generally how much story will fill forty-five pages, but as I write the script, I'm constantly adjusting the balance of various sections by asking myself "What do I want to draw?" and "What do I most want to convey to the readers?" along with other considerations. (For example, "I want to build this part up, and hold back here, and move the most impactful scene to the very end.")

This step of the process is when I decide where to place the emphasis, and as I do so, I form a fairly complete picture in my head of which images I want to put in each panel. In this example, the most important story beat is Josuke awakening, and I built the scene up to that point.

Divide Panels with Rhythm

There aren't any particularly hard-and-fast rules when it comes to dividing panels, and simply by reading many manga, you may pick up on some effective techniques. Rather than read explanations of

the subject, it's more important that you put in the time of studying manga and practicing how to divide panels for yourself. I believe that better results come from not overthinking it. The most fundamental point—and perhaps the only point—is to communicate with emotional honesty through your manga.

Manga is read with a certain rhythm: "Go to the left, to the left, to the left, then, when you reach the edge of the page, go down. Once more, go to the left, to the left, to the left, then, when you reach the end, turn to the next page." The important point is to build an ebb and a flow—basically, by deciding which panels to make larger or smaller. In prose, the writer uses personal judgment to place paragraph breaks to create a structure and provide for ease of reading. I would say the same is true for manga.

Just as the panels in a single page have a rhythm, so do the panels across the manga as a whole. If you look at the panel structure of a sports manga, you'll find that the chapters with competitions will be constructed in a way that builds toward the team's victory.

Another thing to keep in mind is that if the same panel structure is used across many pages in a row, the readers will grow bored. Just like a movie, a manga needs variation; if you use the pattern of close-up, close-up, long shot, start the next sequence with a long shot instead. Sometimes, mangaka will consciously change their panel styles between different series or stories to create a different mood.

Throwing a few curveballs into the design, like using diagonal divisions or setting a panel in a large white space, can prevent readers from becoming bored. I sometimes use round panels, particularly when a character's back is turned to the viewpoint, which can leave the character's emotions unclear. When I want the reader to clearly understand the character's emotional state, I insert a close-up of the character's face in a circular panel.

Japanese Manga's Unique Qualities Are Found in the Rough Layouts

After the script, I draw the rough panel layouts.

The rough layouts, or storyboards, are something I do by feel, and to explain the process in words would be exceedingly difficult. Countless approaches exist to drawing rough layouts, and I can't say if any particular ones are good or not. Some mangaka are able to just wing it and draw the whole thing off the cuff from start to finish, while others may fill up ten pages, then find themselves unsure of how to fill the rest of the pages, and ultimately decide on stretching out an action scene the rest of the way. When I hear vastly different examples like that, it seems like the rough layouts truly are different for every mangaka.

That said, I've heard from some aspiring mangaka who feel they can't draw rough layouts at all. To help those people, I'd like to use an example from the first chapter of *JoJolion*.

In this scene, which I cover in two pages, Joshu roughly shoves Yasuho aside, and then Josuke sees this and becomes angry.

It's in the rough layouts where I believe the decisive difference between Japanese manga and Western comics can be found. In Western comic storyboards, panels are laid out with the most importance placed on good drawing composition, and the sketches focus on the characters' actions. Japanese mangaka, on the other hand, place emphasis on characters' internal thoughts and emotional reactions. This focus on the internal is what sets Japanese mangaka apart.

If a Western artist were to draw this storyboard, I think it might turn out like the example on the right.

I feel that this layout conveys the same story to the reader: Joshu roughly shoves Yasuho aside; Yasuho is knocked to the ground;

Josuke sees what happened; Josuke is angered. From the standpoint of the story, I see no problem here.

But what I most wanted to convey to the reader in this scene is the mysterious boy's (Josuke's) awakening. He wakes up in order to protect the kind woman (Yasuho) who had been caring for him when he mistakenly believes she is in physical danger. Wanting to show Josuke's affection for Yasuho, I allotted this scene two pages rather than one. Doing so also enabled me to establish the main characters in greater detail, and by including more of Joshu in the scene, I aimed to establish a contrast between the two sparring men.

The Viewpoint Doesn't Move

Once I show the rough layouts to my editor, and I receive the go-ahead, I finally move on to drawing the final pages. Sometimes I'll make minor adjustments to improve the pacing, the flow, or other such considerations, but the panel layout and overall drawing placements remain mostly identical to the storyboards.

What I mainly focus on in this step are the compositions. In the scene in the first chapter of *JoJolion*, where Joshu shoves Yasuho, I framed the viewpoint facing Joshu and Yasuho, with Josuke only seen from behind, and the viewpoint remains that way through the scene.

If I were to go into this in detail, there'd be no end to the explanation, but suffice it to say that my approach is similar to that of film—I think of the point of view as being a motion-picture camera that largely remains in one place. The characters themselves can move, but if the camera is constantly moving—here from the left, then there from the right—the shifting perspective will confuse readers. In the worst case, the readers will even get multiple characters

confused with each other. When the scene changes, the viewpoint can change as well, but within the panel layouts of an individual scene, I take a more cinematic approach, though other mangaka may handle it differently.

Forget What You Draw

Once the final art is finished, after sketching, penciling, inking, and—if applicable—coloring, I deliver the pages to my editor. Because I value the feeling of a live performance, I don't correct minor errors.

That moment I deliver the manuscripts, I feel a sense of achievement, but I always maintain the stance that I must forget what I've drawn. I don't revisit and dwell upon the past. Even when I think to myself, "I really made something great this time!" I make myself forget that feeling. I believe that if I let myself feel that I've created a masterpiece, I'll stop getting ideas to create anything else. For that same reason, whenever others compliment me, I never take it to heart. Only children grow through praise. It's the mistakes and failures that provide me hints for where I need to go next, and that allow me to keep drawing.

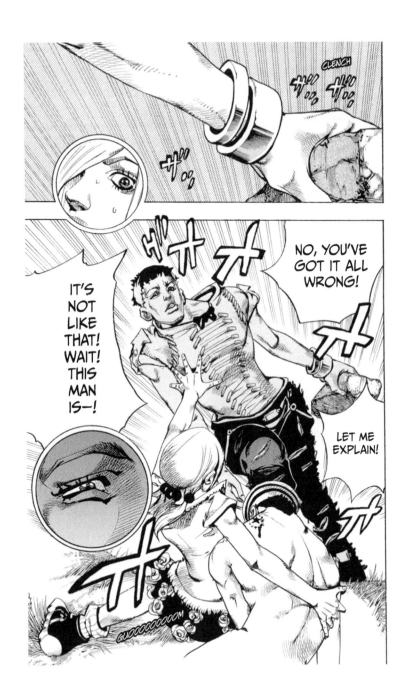

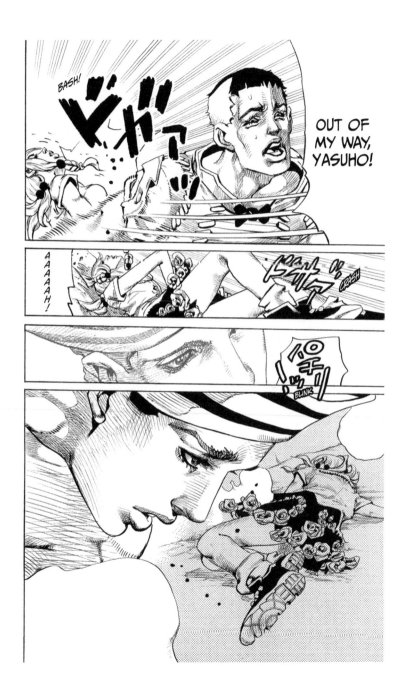

HOW TO CREATE A ONE-SHOT—*THUS SPOKE ROHAN KISHIBE:* "MILLIONAIRE'S VILLAGE"

In 2012, I was hired to write "Millionaires' Village," a one-shot from the *Thus Spoke Rohan Kishibe* series, for publication in *Shonen Jump*.

I'm occasionally asked to judge submissions from aspiring mangaka, and when I do, I look to see if certain criteria are being met. Will the introduction grab readers and draw them into the manga? Are the events portrayed in an engaging manner? Are the characters drawn and established well? In my opinion, "Millionaires' Village" completely satisfies all three points; the story works as I intended it to. By analyzing this work, I will provide it as an example of how to create a manga.

It Began with a Conversation Between Owners of Country Homes

When I was thinking up the story for "Millionaires' Village," my first idea was a battle of manners. The idea was simple, but I thought it would be interesting.

The idea came from a conversation I overheard while I was vacationing. I happened to hear some owners of country homes in the area talking about how wild boars had come onto their property, and since the animals were dangerous, the owners asked a hunting

association to come exterminate the boars. When I heard this, I thought, "It doesn't seem right to build a home on the mountain-side and have the boars killed just because they came around. Surely there was another way to deal with that, right?" I had the feeling that might lead to an idea for a manga, and I wrote the experience down in my notes for later.

Afterward, my editor asked me to write a one-shot for *Shonen Jump*, and my notes gave me an idea: it might be interesting to draw a battle manga about the gods of a mountain who only allow those who pass a kind of test to build homes there. The ostentation I heard behind the words of those country home owners, and its antithesis—respect for nature and the mountain—are linked by the broader idea of manners. That led me to the concept of a battle of manners and the setting of the millionaires' village.

A single core idea is plenty to make a story; there's no need to cram many different ideas into it. This is especially true in a one-shot like "Millionaires' Village," where multiple ideas would muddle, rather than enhance, the story and make it harder to follow.

Decide on the Story as You Write It

It's important for me to note here that at this stage in the writing process, I have not thought at all about what the story will be. I come to my editor with just the basic setup—in this case, Rohan Kishibe does battle with someone as part of a test in a villa location. I tell my editor what kind of manga I want to make, and I see what kind of reaction I get. If my editor responds with interest, it's time to fire up my engines, but sometimes the reaction is not so enthusiastic; during the meeting, I have to be attentive to make sure I can tell the difference.

Sometimes editors can respond with criticism—and that applies not just to the ideas, but to the finished manga as well. Having your flaws singled out, such as by being told that certain aspects of your manga are uninteresting, doesn't feel good, but you have to take the attitude of being grateful for the response, whatever it may be. If your work was really that bad, an editor wouldn't even take it out of the envelope; the very fact that you're getting any feedback at all means your editor hasn't given up on you.

Because creating manga is a solitary endeavor, when you're in the thick of it can be hard to see if you're going in the right direction. That's why, no matter what your editor's feedback may be, you should value it. That said, if you're unable to accept the content of the criticism as valid, don't force yourself to take what you heard at face value, but rather consider the feedback carefully. Something made the editor feel that way; you must find the truth hidden beneath the surface. If you look hard enough, you should be able to find some clue to how your manga can be improved.

But let's go back to my example of "Millionaires' Village." I was able to get the go-ahead from my editor to proceed with my idea. At this point, I was about to begin creating the story in earnest. I had decided to plunge Rohan into a battle of manners, and I knew that Rohan would win in the end, but I had not yet determined how he would do so. As I write my stories, I gradually see where I should take them next.

The First Three Pages Offer a Preview

In terms of the ki-shō-ten-ketsu story structure, the "ki" for "Millionaires' Village" originally began with the scene where Rohan has a meeting with his female editor on what is now page four of the

one-shot. But, realizing that some readers would not be familiar with the character of Rohan, I later inserted a couple pages to introduce Rohan and give the readers the impression that something bizarre could be happening soon.

Rohan serves as the protagonist of "Millionaires' Village," but he also takes the role of the narrator as he tells the readers what happened when he went on a trip to do research for a story. Typically, the beginning is when the mangaka must inform the readers of the basic setting—who is doing what, and when and where, and why and how. But I thought I would ignore that for once and simply focus on Rohan as a character.

On the first page, I drew Rohan from behind, as he bends his hands at the wrists at 90-degree angles for some reason. This is to draw the readers' curiosity and interest, as they ask themselves, "What the hell is that guy doing?" I chose to draw him from behind because I felt that opening suddenly on a close-up view would be off-putting, and also because a more conservative approach at the beginning would create more of a feeling of mystery and suspense.

Rohan's unusual calisthenics routine continues into the next page, where I have him end with the dialogue, "And done. / My warm-up exercises for drawing manga / are complete." This causes the reader to wonder, "If he's a mangaka, why does he need to do warm-up exercises?" thus firmly establishing Rohan as a baffling and unusual character. The mood this creates also suggests that this manga is one where bizarre events are bound to occur and simultaneously foreshadows that Rohan, though a mangaka, is going to go on some kind of adventure.

In this way, I put many different pieces of information in the opening pages while also enticing readers' curiosity as to what Rohan will do.

Relay Information and Introduce Characters Simultaneously

The scene where Rohan meets with his editor follows, and there too I used the art and dialogue to compress a large volume of information into a small number of pages. In the first panel, I use an establishing shot view to convey the introductory information: Rohan and his editor are at a café, during the daytime, discussing his manga. From there, the story begins. Now, let's look at the dialogue.

The 25-year-old editor, Kyoka Izumi, says, "By the way .../ Your deadline for the 45-page submission for the anthology is coming up at the end of the summer. / Have you already decided what you're going to do?" Rohan replies, "Hrm, well, sort of ... / I was thinking something about annular solar eclipses. / What do you think?" Then the editor responds with, "Wow, that sounds so interesting! ♡ / But how about instead ... / you make a manga about buying a summer home in the mountains?"

From this exchange—where the woman reacts positively to the mangaka's suggestion while simultaneously rejecting it, instead pressing him to do what she wants—I establish her as a pushy and selfish editor who doesn't pay any mind to her mangaka's opinions.

In this conversation between Rohan and his editor, an unusual battle is already beginning. The two are not getting along particularly well, and their relationship is rife with conflict. While she doesn't rise to the level of antagonist, I'm signaling that she's going to do something to him that's not in his interest. It takes technique to instill that sense in dialogue without writing or drawing it directly. Communicating information to the reader while simultaneously conveying the characters is of incredible importance. When done right, the characters and story begin to act as one.

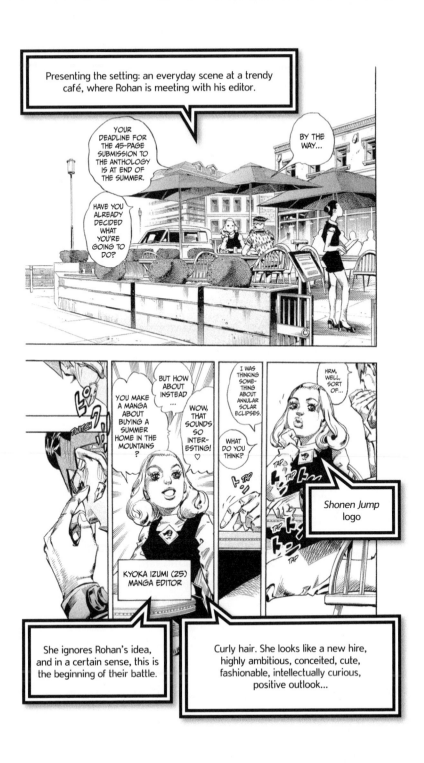

Becoming Fond of Characters as You Write Them

At present time, no female editors are among the *Shonen Jump* staff, but when I thought of the idea of a battle of manners, I felt it would be nice to have him go to the village with a conceited, but cute woman, and so the character was born. With her design, I was going for a woman who appeared to be a new hire, but was highly ambitious, and also cute, fashionable, and intellectually curious, with a positive outlook on life. As a side note, her brooch features the *Shonen Jump* magazine's logo; whenever you use anything trademarked like that, you need to acquire permission.

Meanwhile, Rohan's design features many references to pens in his wardrobe, and his profession as a mangaka is of great importance to him. His hair and headband serve to identify him at a glance. Even in silhouette, if those two features are visible, he's recognizable as Rohan; this is signification at work.

The pair's conversation continues for several more pages. Through the dialogue, the aspect I most wanted to convey was the editor's conceitedness. By reading between the lines, the reader infers that she likely came from an upper-class upbringing, and came into a job with a major publisher without any effort of her own. When I started writing her I didn't like her one bit, but as I got further in the story I began to find her impertinence endearing, and became incredibly fond of her, possibly more so than Rohan, even. This kind of surprise is part of what makes creating manga so fun.

The Decisive Panel—Where You Know You Have the Reader

The panel I wanted to draw ahead of anything else was the aerial

photo of the millionaires' village on page six. This unusual image of a village with eleven mansions, so remote that not even a road connects it to the outside world, would almost certainly capture readers' interest and make them want to read more. This image gave me the confidence that by the sixth page, my audience would keep reading all the way to the final, forty-fifth page.

The view of the millionaires' village also helps build the setting. As I drew the area, I imagined how the residents would go about their daily lives. Since there were no roads, there would be no cars, either, and in their place was a heliport. Because it's a community of the superrich, they would have swimming pools like those found beside Beverly Hills mansions, and their terraces would have parasols and Segways. I put in many details—from a rotary-style path to the placement of each building—to make the village feel extravagant, while the viewpoint, resembling that of a CIA spy satellite, elicits a suspenseful mood.

But no matter how quickly I wanted to get to drawing this decisive panel that kicks off the story, I couldn't start the manga there; I had to first get the readers to become interested in the characters. In manga, the characters hold the greatest importance, not the story. This rule must never be forgotten.

From the beginning of Rohan and the editor's meeting on page four, to page thirteen when they depart for the village, I put greater emphasis on the characters than on the story. Just one example of this is when Rohan is listening to his editor's proposal and says, "Hey, hey, hey, hey, hey!" with a sour expression. In total, the entire first half of "Millionaires' Village" is focused on developing characters and setting at the same time.

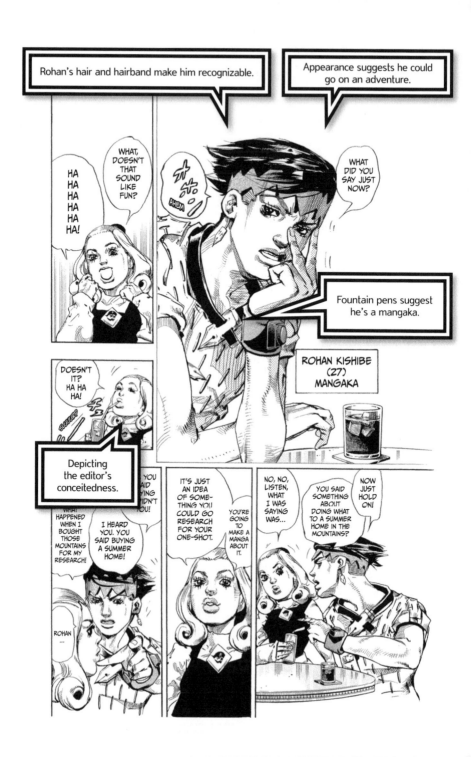

I FOUND THIS PLACE ON GOOGLE MAPS.

TAKE A LOOK AT THIS.

LISTEN, I'M JUST TALKING ABOUT AN IDEA, SOMETHING TO LOOK INTO.

FOO

SWIF

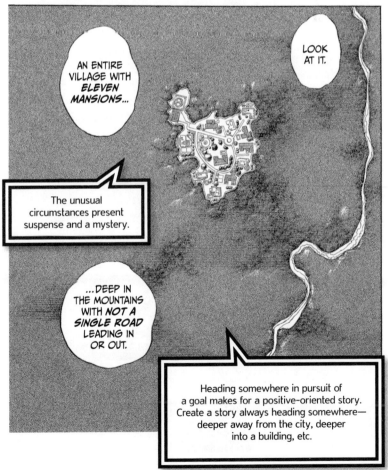

AN ENTIRE VILLAGE WITH *ELEVEN MANSIONS*...

LOOK AT IT.

The unusual circumstances present suspense and a mystery.

...DEEP IN THE MOUNTAINS WITH *NOT A SINGLE ROAD* LEADING IN OR OUT.

Heading somewhere in pursuit of a goal makes for a positive-oriented story. Create a story always heading somewhere— deeper away from the city, deeper into a building, etc.

An angle that suggests satellite imagery.

The parasols and Segways help build the setting of the wealthy community.

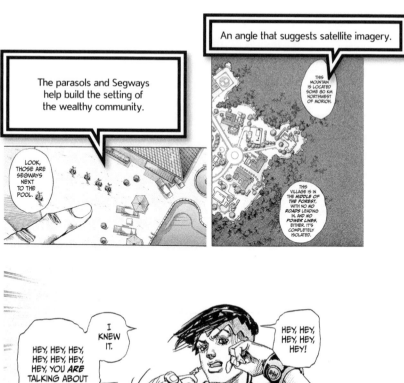

Rohan's dialogue and expression reinforce his personality.

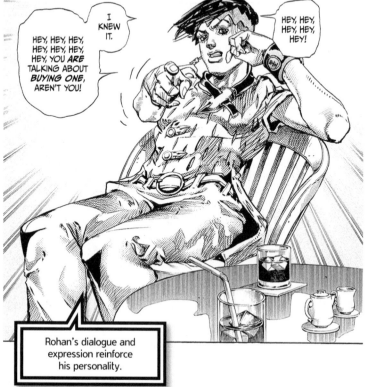

Curiosity Is Rohan's Motivation

When the editor mentions that everyone who has bought a summer home in the village came into great riches after the purchase—hence the name, Millionaires' Village—the mystery ratchets up. Even Rohan, who had been reacting testily to the editor's pushiness, begins to think he might not mind visiting the village after all. In other words, his motivation—a crucial aspect of character development—is his curiosity.

Rohan's flaw, or weakness, depending on how you look at it, is how he lets himself be swayed by the editor's suggestions, rather than persisting in his own idea having to do with annular eclipses. I don't want to make manga about heroic characters all the time; where I can, I like to put in flawed, more human characters.

The "ki" of the ki-shō-ten-ketsu structure ends here, and the departure of Rohan and his editor for the millionaires' mysterious village marks the beginning of the "shō" section. The two venture toward an unusual situation, and they seem to pair well as characters, but the one thing I don't do is have them backtrack for any reason. Here, too, I'm adhering to the "always rising" rule as I outlined in the chapter on story.

The Three Roles: Protagonist, Adversary, and Ally

When the two arrive at a manor for sale in the millionaires' village, the front gate opens to reveal a boy who offers to guide them within. The boy is an odd character who seems doll-like and is eerily expressionless, and appears highly intelligent as well. His looks announce him as filling the role of the adversary. The braided hair and vaguely snobbish attire typify a shonen manga villain, and here, I'm very

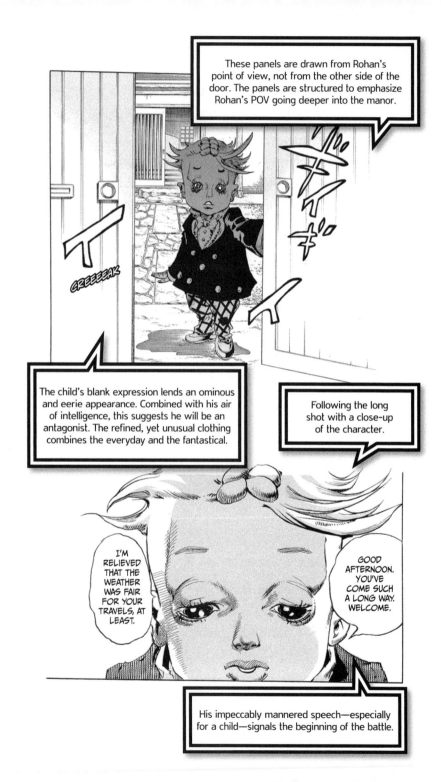

much playing by the book. The basic approach in a one-shot manga is to limit the number of characters but to fully flesh them out. The key number is three: protagonist, adversary, and ally. A short one-shot with only forty-five pages can't sustain ten or twenty characters without some remaining too vaguely defined.

I opened with something unexpected by having the guide to an extravagant estate be a little boy, and then I aimed to make him so well-mannered as to become creepy. At first, I felt an older, more butler-like character would suffice, but then I thought that it would make for a more overwhelming emotional blow to have a little child critique their manners—an area where even adults aren't so confident—and I decided to make the character a child.

Researching Manners to Perfection

The child's impeccable manners are enough to suggest that something deeper is afoot, and the suspense continues to build. An example is when the child smoothly greets them in a way that even an adult might stumble through, and says "Good afternoon. / You've come such a long way. / Welcome. / I'm relieved that the weather was fair for your travels, at least." Because these details play a direct role in building suspense and fear, I put great effort into the boy's dialogue, writing his lines, having them checked by experts in etiquette, and writing them again until I was sure there weren't any mistakes.

As part of building the character of the boy guide, I included a close-up profile of him bowing, silent and expressionless, as he beckons Rohan and the editor inside. If my editor had told me I needed to reduce my page count, that is not a panel I would lose.

Because the setup of the story meant that the boy would pose a more formidable adversary the more his manners were correct,

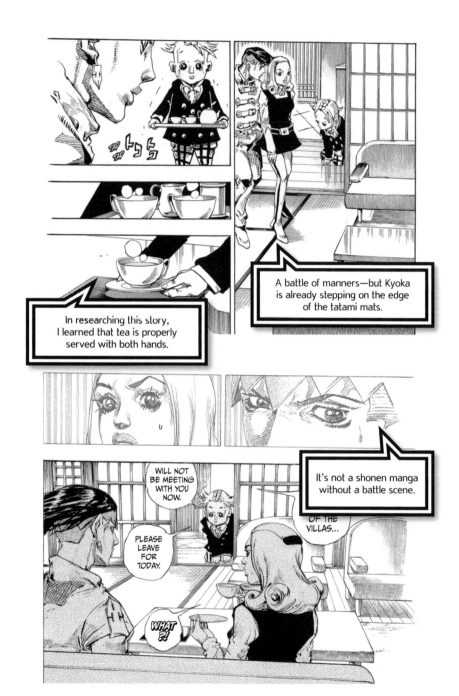

I researched everything he does, from his gestures to the way he removes his shoes, the way he sets out the tea, how he sits, and so on, down to the most casual of actions, and then I used that research as a basis for my drawings. After I showed the manga to an expert in etiquette, I even made one correction. This was an important matter; because this aspect was a part of the setting, I had to draw it right, or the world wouldn't be cohesive.

One other decision I made as part of the setting was that once Rohan arrived at the manor, I would draw the scene from his perspective, almost as if Rohan's eyes were our camera. Rather than provide views from many differing perspectives, I would build the space from the outside moving in as we enter the manor with Rohan. This may be getting into more minute technical detail than is necessary, but I made an effort to follow Rohan's perspective from when he's in the shaded woods to when he reaches the mansion's inner room.

Using Manners as a Battle

As soon as they set foot inside the mansion, the battle of manners between Rohan and his editor and the boy guide begins. Following the ki-shō-ten-ketsu structure, this is now the story's "ten."

At first glance, a battle of manners seems rather low-key, but I'm still following shonen manga's royal road. I lay the groundwork by showing the editor making various faux pas, while the boy continues to have impeccable manners, and the scene builds through a "ten-ten-ten-ten" structure typical of *Shonen Jump* battles. When the protagonist does something, the enemy responds, and when one surpasses the other, the other takes it to the next level—the boy places their cups, and they have to decide how to take them; the boy offers corn, and Rohan has to find the correct way to eat it.

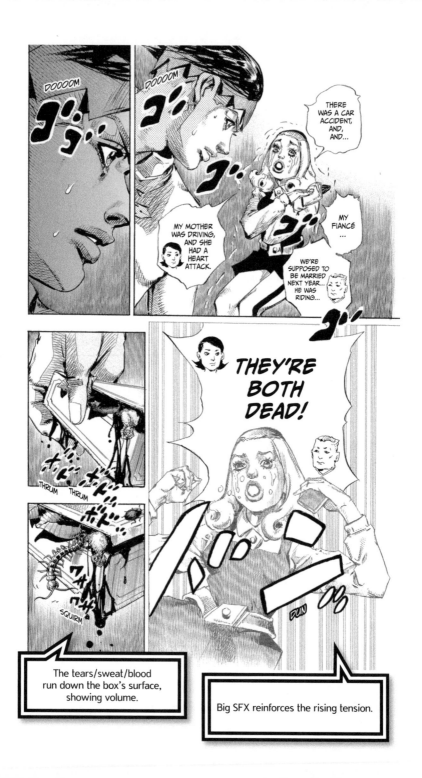

The tears/sweat/blood run down the box's surface, showing volume.

Big SFX reinforces the rising tension.

As the story builds, I begin to add speed and focus lines (largely absent from the first half) to heighten the sense of speed and impact in the drawings. I also heavily use my trademark "ドドドド" ("doooom") SFX to serve the same role as that of a movie's sound effect track, and by the climax they're even a little intrusive.

But a *Shonen Jump* manga needs more than a battle; it must also have something to grab the readers emotionally, like a display of friendship. In this story, the editor's hubris puts her into a bad spot, but Rohan battles to save her. Once I added the element of the protagonist fighting to help someone else, I felt confident that this was a manga I could deliver to the *Shonen Jump* editors

In this story, I don't believe that Rohan cares much for the editor, but when she winds up in danger, he can't make himself abandon her—even if the battle to save her is one where he is at a disadvantage. This exposes a kindness beneath his cool exterior. If he were to say, "I'm not sure I can win this one. I'll just go home instead," that would be movement in the negative, or falling, direction. The story must always move in a rising direction, and in this case, that means solving the mystery and continuing onward.

Ending with Defeat Is Acceptable

The boy guide is not actually their direct adversary; the gods of the mountain are working behind him. When I decided on gods for Rohan's opponent, I questioned how I would ever get my characters out of it, but when it came to their possible victory, I set a rule and obeyed it: they would win by using correct manners.

Let's go back to where I got the idea in the first place: the boar extermination. The summer home owners may have been afraid of the beasts, but killing the boars was an act of human arrogance; I felt

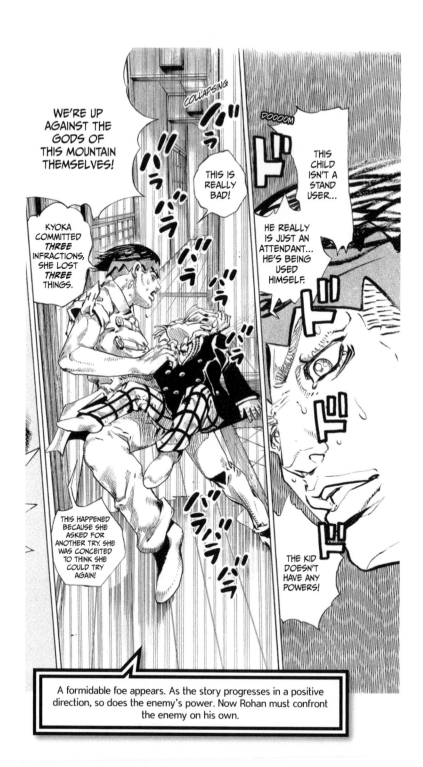

A formidable foe appears. As the story progresses in a positive direction, so does the enemy's power. Now Rohan must confront the enemy on his own.

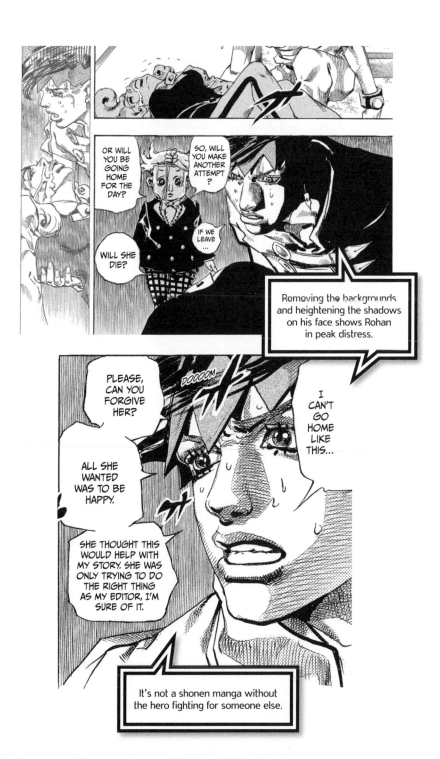

that if they wanted to live on the mountain, they should obey the mountain's rules. Consequently, with "Millionaires' Village," Rohan had to find victory in the battle of manners in accordance with the rules of the mountain. No matter how hard the fight, I absolutely could not have someone suddenly show up to save the day, or have some superpower suddenly awaken within the editor, or have the gods appear and say, "You're a good person, so we forgive you," or anything like that. Because the underlying theme of my work is a paean to humanity, it's crucial that my characters find a way through their challenges by using their own strengths.

If I ever wrote a character into an utterly unwinnable situation, I would rather have that character lose with honor and bravery than to rely on an outside force. In "Millionaires' Village," I found a way out for Rohan, and he uses his Stand's ability, which is to control others, to force his opponent into breaching a rule of etiquette, and in doing so finds victory, which then brings the story to its "ketsu" stage.

From Short Form to Long Form

To recap: I came up with the idea of a battle of manners, then put in the characters of Rohan Kishibe and a somewhat conceited editor, and then progressed the story along the ki-shō-ten-ketsu pattern. As for the setting, I aimed for something along the lines of Seishi Yokomizo's novels, *The Inugami Clan* and *Yatsuhaka-mura* (The Village of Eight Graves) —in other words, an otherworldly version of present-day Japan. When it comes to manga, the characters and setting are most important, with story following after.

For the cover of "Millionaires' Village," I used a backdrop of a waterfall reminiscent of the painter Hiroshi Senju's works, and also drew several baby chicks gathering affectionately around Rohan. My

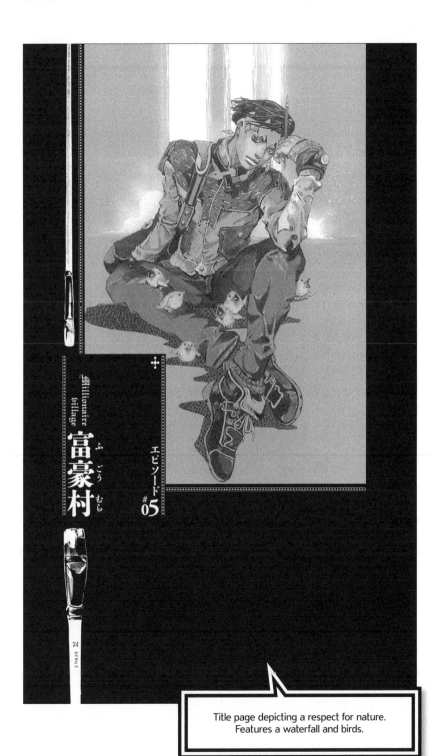

富豪村

Millionaire Village

ふ ごう むら

エピソード #05

Title page depicting a respect for nature.
Features a waterfall and birds.

intent was to reflect the theme of respect for nature. "Millionaires' Village" is a short manga, just forty-five pages as was requested, but if it were part of a longer manga, the process would have been basically the same. You can think of longer-form manga as simply building upon the same things you do for a short manga, or possibly repeating them. Therefore, rather than jumping straight to attempting a long-form manga, I think it makes better sense to practice on short-form pieces and to only move on once you can get those right.

IN CONCLUSION

How to draw manga—does such a thing really exist? Is there a surefire way to draw manga and have a hit? Can there be a manual for making a manga that will become a popular classic?

It's likely that some people will have completely different opinions from what I've written in this book, and maybe no small number of mangaka would become enraged upon reading this book and consider it to be filled with misinformation. I wouldn't be surprised if others think me presumptuous to write like I have. Or, some readers may interpret what I've written in a manner I didn't intend.

Because manga are created out of the heartfelt passions of their artists, I can't offer any proof that this or that specific method is correct. To imagine the existence of some universal answer would be presumptuous, and such arrogance is best avoided. Besides, there need not only be one correct way.

That said, sometimes everything in a manga just works. It may happen only rarely, but sometimes, when creating or reading a manga, everything works in harmony, and the result feels as smooth as a finely aged Scotch.

Each aspect of the story—the protagonist's personality and motivations, the reasons they are where they are, the people around them, like their family—are all connected and working in unison, and not

a single further panel or line of dialogue could be trimmed away; the manga is written to a perfect *smoothness*. Sometimes a manga just visually "clicks" from the rendering of the light to the characters' expressions and dress. It can make you wonder why that character has never existed before this moment. It feels like you can see all the way through to the heart of the manga.

Sometimes it makes me feel the presence of perfection, like when a physics theory describes the rules of the universe; it's like beautiful music, a flowing collection of notes with not one out of place.

I like to call the path toward this state the "golden way."

The golden way to creating manga has existed since long in the past. I wrote this book in hopes of bringing everyone who reads it at least a little bit closer to being on that road.

The golden way is the correct way, and though we all may come at it from different directions, it's a common path. It encompasses everything drawn and experienced as mangaka, every meeting and discussion with our editors, and all forms of art, including literature and critique, paintings and sculpture, movies, even fashion and photography.

The advancement of culture and art is a living process. As I've learned through my own experience and the achievements of others, I've come across various concepts that feel like they just work. Now, these theories have found a place in this book.

Writing this book feels akin to a worker divulging his company's trade secrets to another, or a magician revealing his illusions, or a chef giving away a secret family recipe.

In April 2015, my first editor, whom I met when I brought my manuscript to Shueisha's *Weekly Shonen Jump* magazine at the age of eighteen, reached his mandatory retirement age. At time, I doubted whether revealing the tricks of the trade was a suitable way to show

my appreciation, but in the end I felt compelled to make a record of all my experiences, everything he enabled me to learn about the royal road to creating manga.

But I want to make this absolutely clear: the golden way is not a manual to creating manga.

The golden way is a path to further developing your craft. It's the path to get from where you are to where you're going. It's the path to help you search for where you go next.

Therefore—and this may be a strange thing to write—you must not create manga exactly as I instructed in this book. If you simply implement the golden way I outlined in these pages, you won't make any new discoveries.

Use this book as your base to make a brand-new manga, to make a powered-up version of manga, or maybe even something 100 percent different, something the exact opposite—something that completely ignores this book. I wrote this book because *those* are the kinds of manga I want you all to create.

I want this book to be a kind of map in which are recorded the many different roads to creating manga.

It's a map for climbing undiscovered mountains. It's map for exploring undeveloped and undiscovered lands.

It's a map to bring you home alive when it's time for you to advance, but on the way you got lost, or became unsure, or lost sight of the path, or ran into walls or cliffs. Come back to this golden path, rest yourself, calm your thoughts and find clarity, then keep going onward.

This book was written to be that map. (Even if it might only be written for one person, somewhere out there.)

It's my deepest wish that this book will serve as a good map for all who read it.

As the final words, I'd like to offer my heartfelt appreciation for Yuko Kato, who offered me spot-on advice on writing and structuring this book, and to everyone on the editorial staff at Shueisha Shinsho.

March 2015
Hirohiko Araki

About the Author

Hirohiko Araki made his manga debut in 1981 with the Wild West story *Poker Under Arms*. He experimented with several genres, including mystery (*Mashonen B. T.*) and action-horror (*Baoh*), before beginning *JoJo's Bizarre Adventure* in 1986. Propelled by imaginative storylines, weird imagery and individualistic artwork, *JoJo's Bizarre Adventure* is one of the longest-running and most popular shonen manga ever. Araki's current works include a new series set in the JoJo universe, *JoJolion*.